AAD
FASHION
#TAIWAN

AAD 亞洲傑出時尚創作精選

Prologue

AAD 亞洲傑出時尚創作精選，是一本收錄亞洲各國在時尚創作領域中，不論是在創作
敘事手法、風格獨特性、視覺表達技巧等面向上表現傑出的優秀創作者。我們藉由這樣
的出版計劃，推廣優秀的時尚設計師與精彩的創作作品，透過簡要的訪談形式，讓更
多對於亞洲設計創意有興趣的讀者們，更加能夠深入瞭解作品背後設計師的用心，並分
享如何在兼顧自我理想與商業現實考量中取得完美的平衡。新世代的設計師們更想藉著
創作去演繹出獨有於這個時代的新設計語彙，在一個變化無比巨大且溝通快速更替的時
代，設計作品為大家留下來豐富而多元的人文哲思相信更加值得我們去好好品味。

"AAD fashion designer in asia" will not only record the artist but focus on describing the
style, techniques and visual expression of the artist. We would like to promote those
fashion designers and their remarkable works with this meaningful project. Through
a brief interview, readers who are more interested in Asian design ideas will be able
to gain a better understanding of the designer's intentions and share how to strike a
balance between self-realization and business reality. New generation of designers
who want to use to create a unique interpretation of this era of new design vocabulary,
in a very huge change and rapid change in the era of communication, designers for
everyone to stay elegant and elegant human philosophy I believe it is more worthy of
our taste.Besides, we are also planning to have a thematic exhibition and an exchange
seminar. Furthermore.

總編輯 陳育民　　Chief Editor　CHEN YU-MING

Contents

OVKLAB

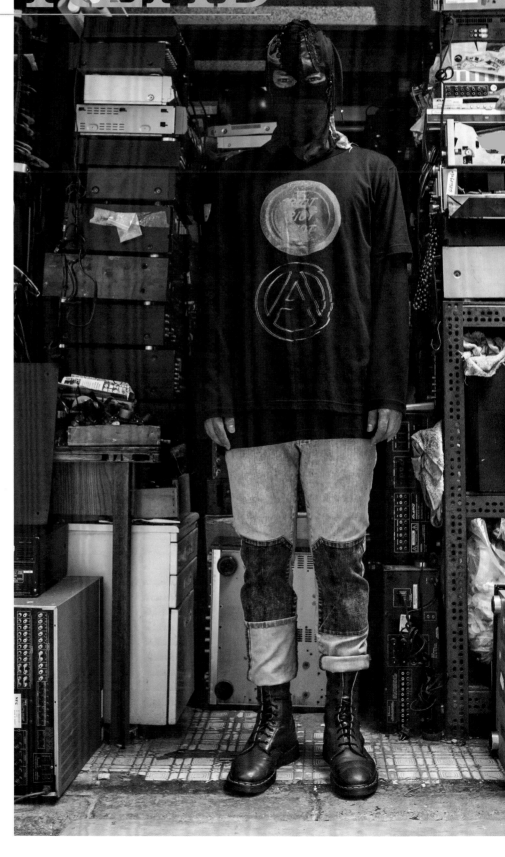

NATION /
TAIWAN

DESIGNER /
Chuang Chewei

BRAND /
OVKLAB

國家 /
台灣

設計師 /
莊哲瑋

品牌 /
OVKLAB

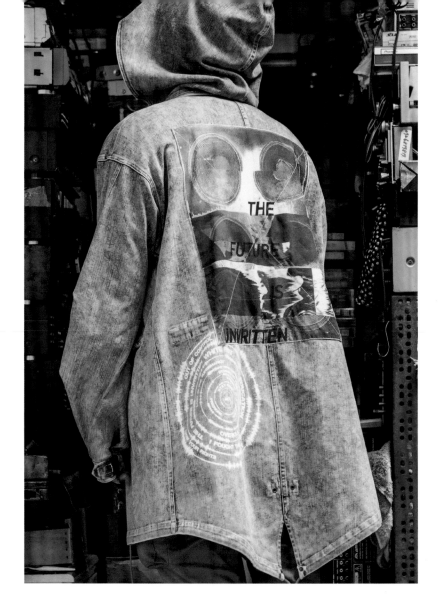

15SS / White Riot

2015

The 2015 Spring & Summer Collection is inspired by the song from the legendary Punk band "The Clash", and the mid-70's punk scene. Base on the cultural landscape of the punk era, and it's attitude of the rebellious generation. Using punk rock inspired graphic patterns, and the vintage mili- tary outfit cuttings to create a series of apparels that shouts both vintage and modern.

OVKLAB 2015 春夏系列以七零年代中期 "衝擊樂隊" (The Clash) 的單曲 "白色暴動" (White Riot) 吶喊出的思想為主題靈感起源,龐克文化的集體時代地景,叛逆青年世代的憤怒姿態與實踐扭力、龐克搖滾的聲浪音軌縈繞在設計 思緒中,轉譯為一系列圖像設計、版型風格考究、材質面料探索與服裝工序表現,企圖以品牌獨特的設計視野,熔接街頭與時裝的殊異服飾形態。

AUTHOR SUMMARY

Founded in 2003, OVKLAB is inspired by the American HeavyMetal band OVERKILL. The brand grows from the subculture streetwear style in the early days to now; a more mature and histreet style. OVKLAB feeds off from Rock N' Roll music & culture, base on the philosophy / slogan "The Future Is Unwritten", OVKLAB experiments on combining high fashion elements with a washed, vintage style looks, to build a fashionable streetwear brand.

Che Wei Chuang is not only the design director but also an artist, his work exhibits in many places sush as Taiwan, France, Italy, Hungary.

Please describe yourself in a few words
It's like weaving a net when I'm elaborating the meaning. Just like Edward Yang's movies.

創作者簡歷
OVKLAB,成立自 2003 年,其名源於 80 年代美國重金屬樂團 OVERKILL,從早期次文化的街頭風格發跡,成長至今日時裝造型的樣貌。品牌精神取材搖滾樂文化,並以 THE FUTURE IS UNWRITTEN 作為核心,將時裝設計融入古著元素,呈現次文化主題的系列款式,運用解構技巧重新定義風格,打造出高端街頭時裝品牌。

莊哲瑋從事服裝設計與藝術工作,作品多次在台灣、法國、義大利、匈牙利等地發表。

一句話形容自己
我鋪陳意義的時候像在織一張網,像楊德昌的電影。

16SS /
Blowin' in the wind

2016

The 2016 Spring & Summer Collection is inspired by the hippie culture, from the hippie movement of the 60's and anti war movement. "The Beat Gener- ation, Howl, Woodstock, Protest, Psychedelic, Tie Dye, Procession, Anti War", are some of the keywords and phrases. The collection revisited many vintage pieces as guidelines and reconstruct and renew to build a new contour.

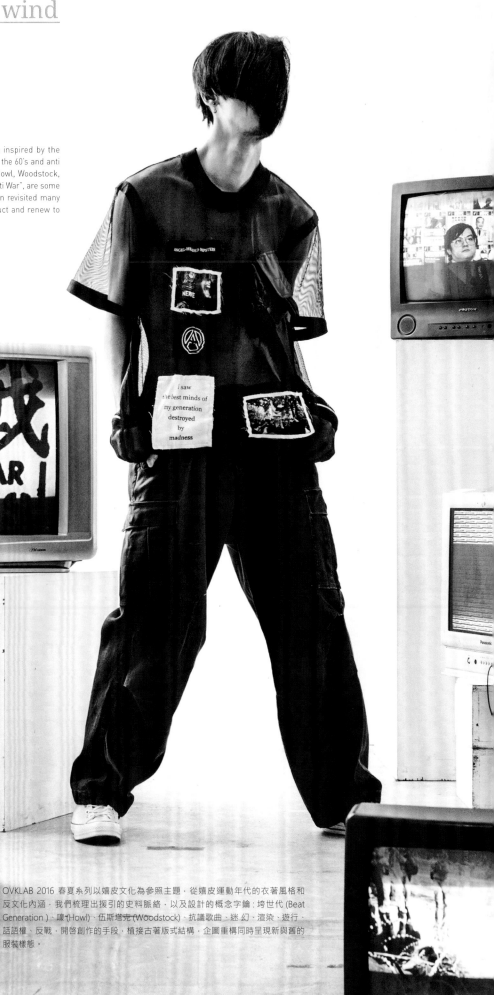

OVKLAB 2016 春夏系列以嬉皮文化為參照主題，從嬉皮運動年代的衣著風格和反文化內涵，我們梳理出援引的史料脈絡，以及設計的概念字鑰：垮世代 (Beat Generation)、嚎 (Howl)、伍斯塔克 (Woodstock)、抗議歌曲、迷幻、渲染、遊行、話語權、反戰，開啓創作的手段，植接古著版式結構，企圖重構同時呈現新與舊的服裝樣態。

16AW/
Dark entries

2016

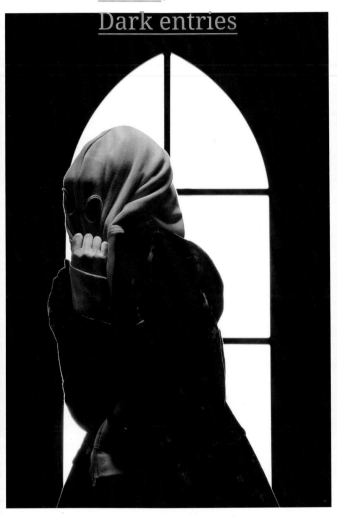

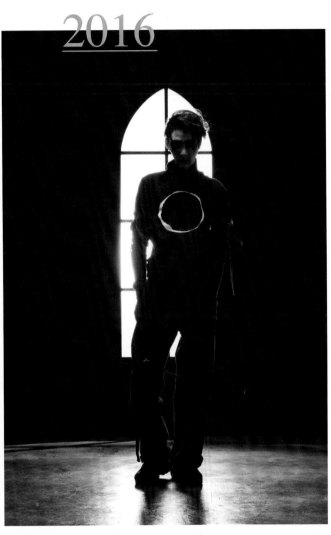

The 2016 Autumn & Winter Collection is inspired by the Goth Rock scene, muse over The Bauhaus. Base on the Gothic music, its culture and its fashion style. The key concepts includes Black, Darkness, Shadows, Bondages, PostPunk Genre, Gothic Architectures, reconstructing vintage clothing pieces with a modern perspective. The collection experiments with new ways to present a vintage gothic fashion style.

OVKLAB 2016 A/W 系列以哥德搖滾 (Gothic Rock) 為參照主題，包浩斯樂團 (BAUHAUS) 是本季的繆斯，從哥德次文化的反叛裝扮風格與音樂表現，我們梳理出設計的概念字鑰：黑色、幽暗深沈、陰影、捆綁束縛、後龐克、歌德建築，開啓創作的手段，植接古著版式結構，企圖重構同時呈現新與舊的服裝樣態。

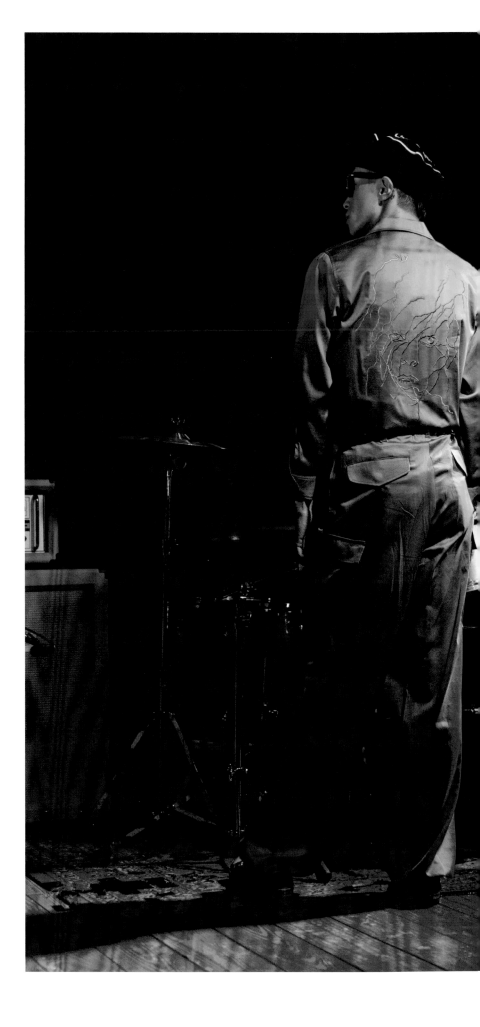

na Be Your Dog

7

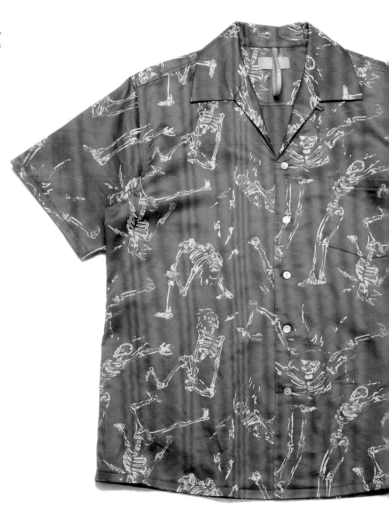

The 2017 Spring & Summer Collection is inspired by the legendary Pro- to-Punk band "The Stooges", based on the band's concise, repetitive, rugged and raw music style, and of course Iggy Pop's intense, instigating body languages; physical, twisting, distorting, howling, primitive, raw, hermaphrodite-ish. The collection uses vintage pieces as base silhouettes to deconstruct, and recreate with motif patterns, repeated graphics, purposely reverse fabrics and parts to portray Iggy's performance style and body languages.

OVKLAB 2017 S/S " I Wanna Be Your Dog " 系列，靈感源自前龐克 (Pro-to-Punk) 樂團 " The Stooge " 簡約、重復、粗糙的曲式風格，以及主唱 Iggy Pop 強烈煽動的舞台身體形象；顛倒、扭曲、嚎叫、更原始的、物質的、雌雄同體，表現在服裝上我們以古著版式為基礎進行解構、重組或拼裝、反覆的圖像與標語符號、重複的服裝結構，上下、正反、前後的穿著錯置。

LIOU SHING-LUEN

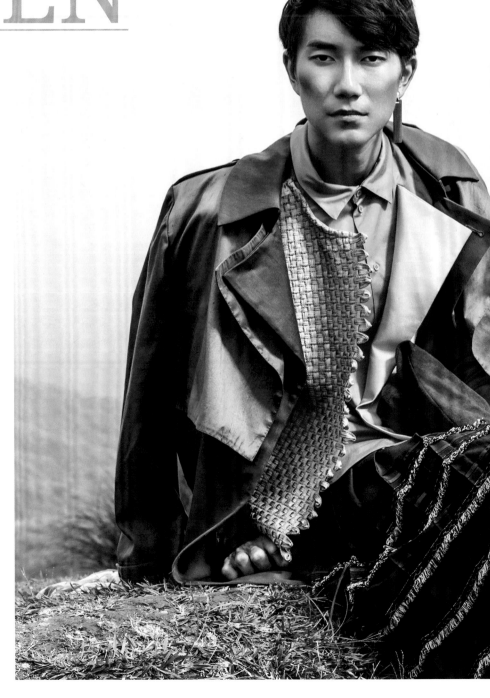

NATION /
TAIWAN

DESIGNER /
Liou Shing-Luen

國家 /
台灣

設計師 /
劉興倫

AUTHOR SUMMARY

Taiwan-based fashion designer, Liou Shing-Luen has shown his works in various exhibitions and competitions in Taiwan, Hong Kong, and China. His graduate collection "Gentry in the Mountain" won the first place of Taiwan Fashion Design Award in 2015, and also his other collection "Nostalgic Silent Beauty" was nominated in Chinese Jeanswest Cup Casual Wear Design Competition and displayed in "From Castiglione to the 21st Century" art exhibition.

Shing-Luen grew up in a rustic town, Pingtung, but studied in a prosperous and diverse city, Taipei. During his college years, he once went to Sweden as an exchange student and travelled more than 10 nations in Europe. Observing and pondering the cultural differences are his joy. Loving to apply different cultures and social issues as the design elements, he hopes, through his works, his audience not only have the visual sensations but also introspect and reflect in their minds.

Please describe yourself in a few words
The stubborn but honest person who likes changes.

創作者簡歷

來自台灣的服裝設計師劉興倫，曾於台灣、香港、中國等地參賽與參展，其畢業製作「紳入山林」獲得 2015 年臺灣時裝設計新人獎首獎，2016 年系列作品「莫沒默墨」入圍於中國真維斯杯休閒裝大賽並於「從郎世寧到 21 世紀」藝術展中展出。

生長於純樸的屏東卻在繁忙與多元的台北念書，大學期間曾於瑞典做交換學生 並於留學期間周遊歐洲 10 餘國，觀察與思考文化間的差異是他的樂趣，喜愛運用不同的文化與社會議題當作設計元素，希望透過作品可以讓觀賞者除了視覺的感受以外還能有內心的反省與反思。

一句話形容自己
喜歡變化的固執老實人。

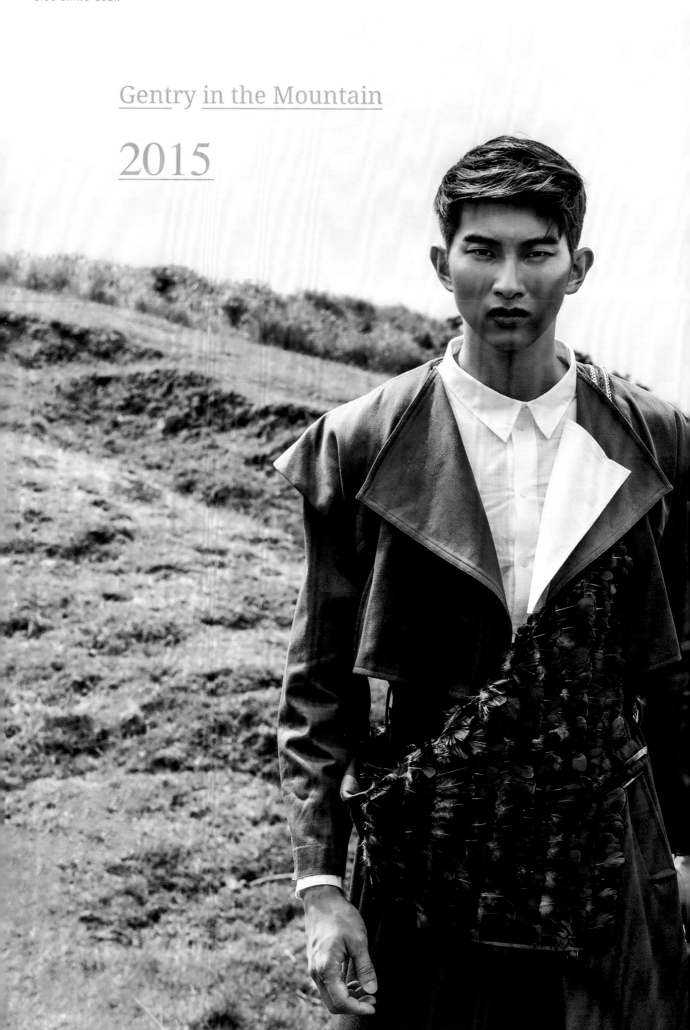

LIOU SHING-LUEN

Gentry in the Mountain

2015

紳 入 山 林

Fusing the images of Taiwan's native bird species, Bunun aboriginal cloth- ing, and modern gentlemen menswear, the collection aims at demonstrating the natural and human beauties of Jade Mountain.

將台灣原生鳥類、布農族原住民服飾與現代紳士男裝等元素融為一體，闡揚玉山內在的自然美好與人文內涵。

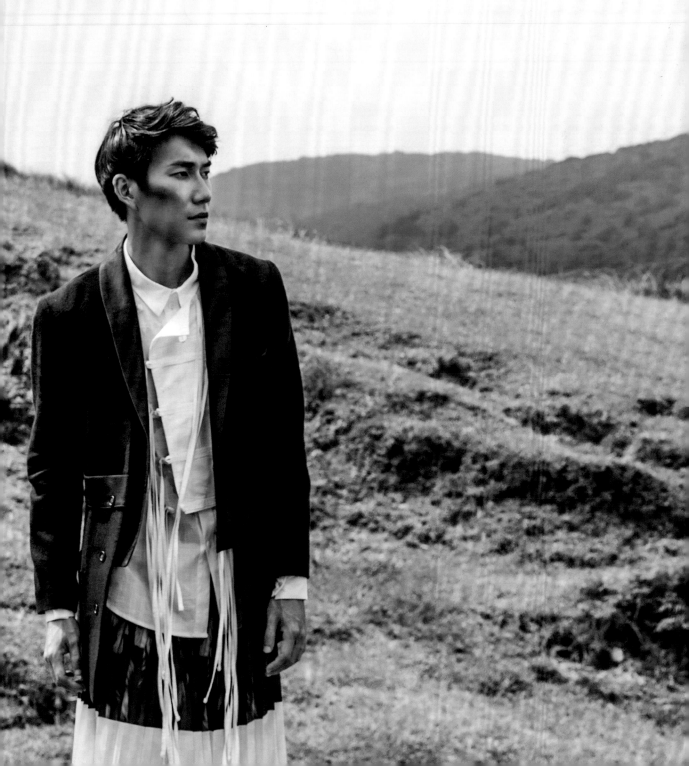

Nostalgic Silent Beauty

2016

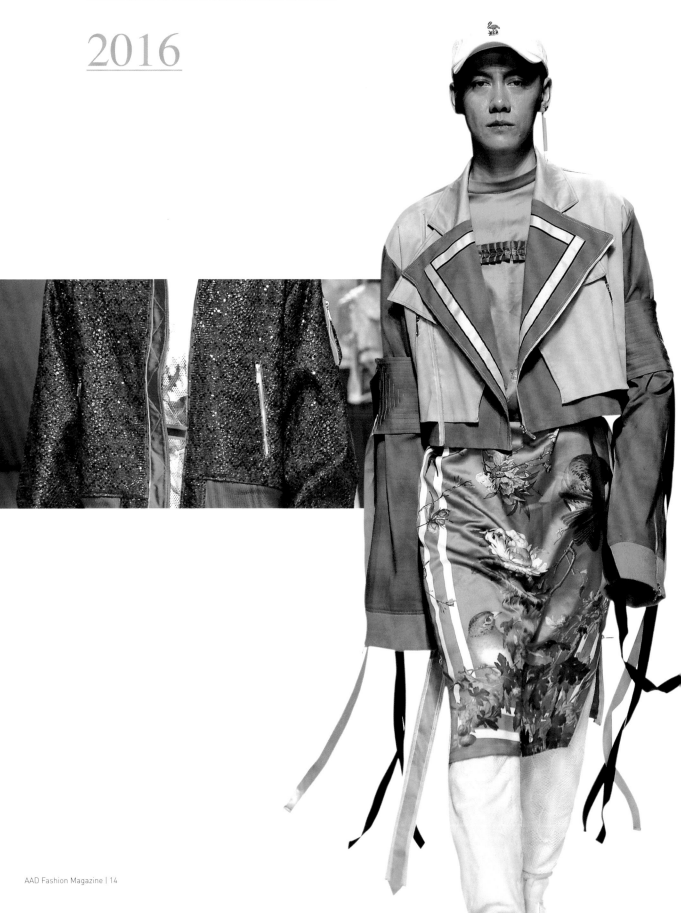

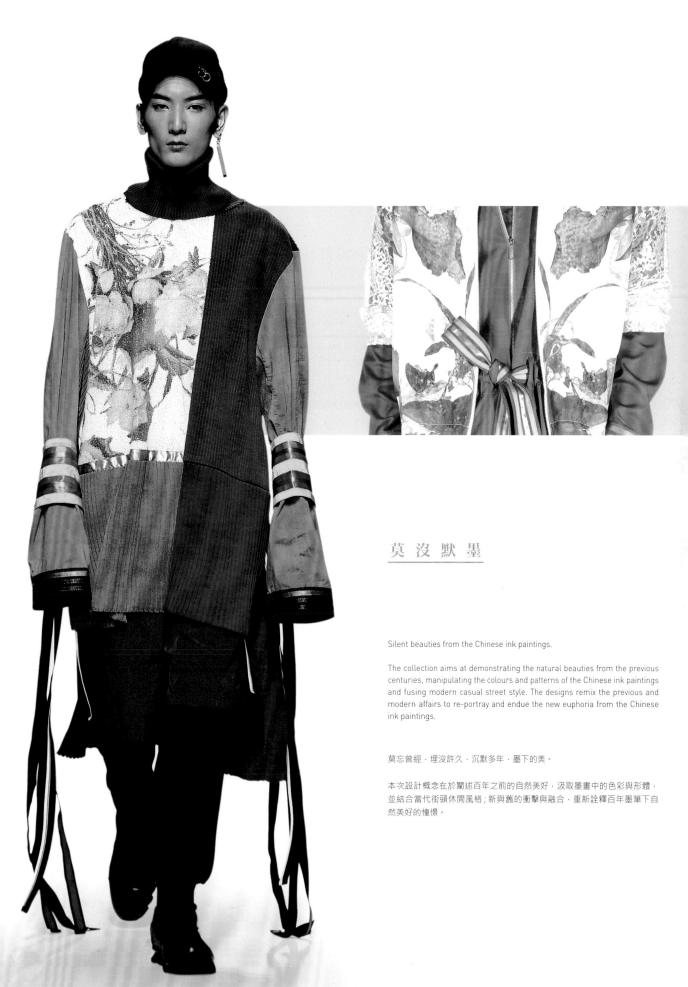

莫 沒 默 墨

Silent beauties from the Chinese ink paintings.

The collection aims at demonstrating the natural beauties from the previous centuries, manipulating the colours and patterns of the Chinese ink paintings and fusing modern casual street style. The designs remix the previous and modern affairs to re-portray and endue the new euphoria from the Chinese ink paintings.

莫忘曾經，埋沒許久，沉默多年，墨下的美。

本次設計概念在於闡述百年之前的自然美好，汲取墨畫中的色彩與形體，並結合當代街頭休閒風格；新與舊的衝擊與融合，重新詮釋百年墨筆下自然美好的憧憬。

CHEN YING-CHIA

AUTHOR SUMMARY

Taiwanese,23 years old,graduated from Fu Jen Catholic University Depart- ment of Textiles and Clothing fashion design .Have been selected for IFFTI Fashion Illustration Contest,and won the Italy ISTITUTO MARANGONI fashion bussiness course full scholarships,represented Fu Jen Catholic University Department of Textiles and Clothing published graduatin collection in Zhejiang Sci-Tech University Institute of Clothing. One of the graduation collection "SPACE OUT PROJECT" was selected for Tokyo New Designer Fashion Grand Prix as the theme "OVERVIEW EFFECT".

Please describe yourself in a few words
Think outside the box,be a Game Changer.

NATION /
TAIWAN

DESIGNER /
Chen Ying-Chia

國家 /
台灣

設計師 /
陳盈嘉

創作者簡歷

23 歲‧台南人‧畢業於天主教輔仁大學織品服裝學系服飾設計組‧在學期間曾入圍 IFFTI 國際服飾畫設計競賽‧並得到義大利 ISTITUTO MARANGONI 短期課程全額獎學金‧也曾代表織品系前往杭州浙江理工大學服裝學院畢業展交流‧大四以服裝系列" SPACE OUT PROJECT" 於畢業展獲得佳作‧近期以作品" OVERVIEW EFFECT" 得到 2016 東京新人設計師時裝大賽佳作獎‧是唯一入圍的在台學生。

一句話形容自己

打破框架‧當一個 *Game Changer*

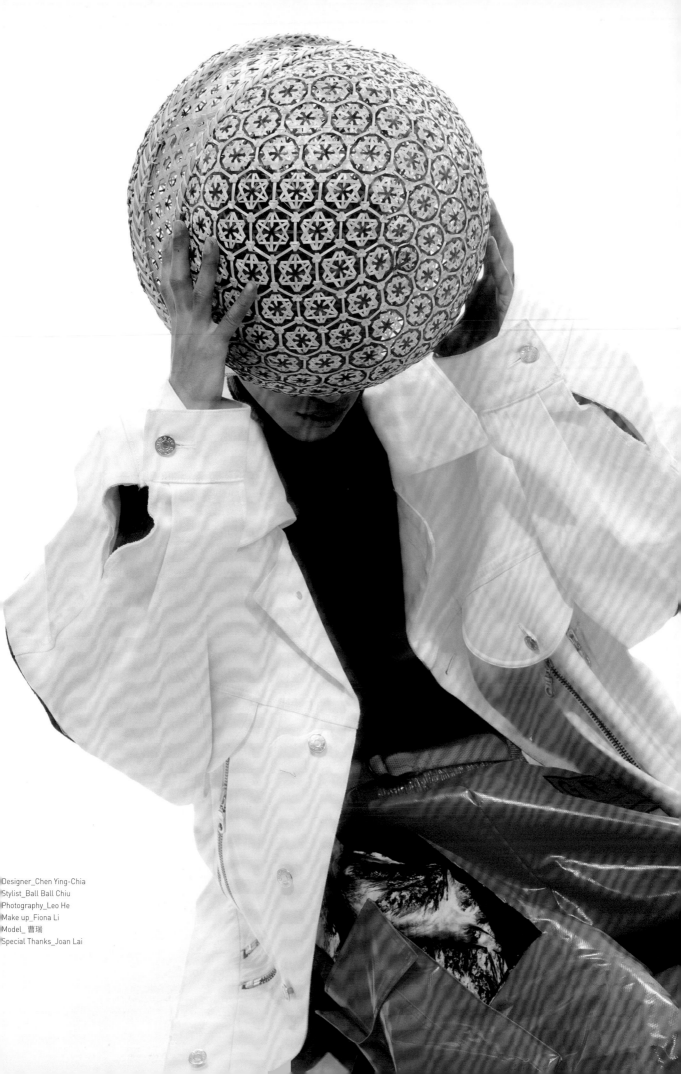

Designer_Chen Ying-Chia
Stylist_Ball Ball Chiu
Photography_Leo He
Make up_Fiona Li
Model_ 曹瑞
Special Thanks_Joan Lai

SPACE OUT
PROJECT

2016

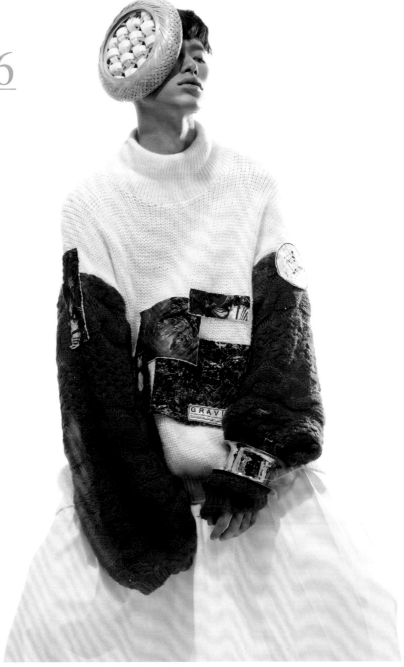

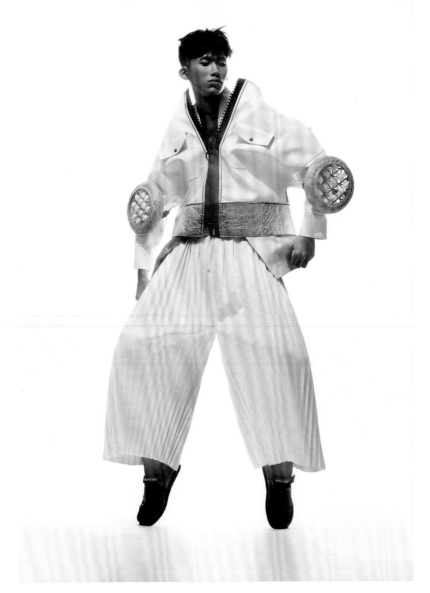

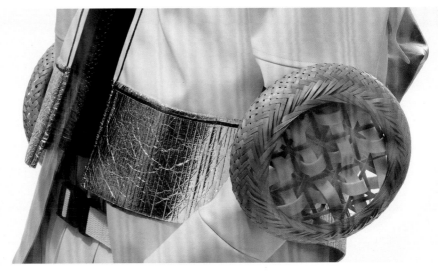

A theory called "OVERVIEW EFFECT" wrote by Frank White in 1987, which is about astronauts look back and gaze the Earth during the space travel. It makes them rethink the bond between humans and the mother Earth from the angle of the universe.

I combined bamboo weaving, embroidery, natural indigo dye and hand knit techniques in this work to reshape the spacesuit, as if I were in the outer space affected by the overview theory.

根據綜觀效應 (overview effect)1987 年由 Frank White 所著作的書描述，太空人在航行過程中回頭凝視地球，讓他們能以宇宙的角度重新思考人類與地球間的關係。

這套作品我結合竹編、刺繡、藍染和手織技術去重塑太空裝，彷彿我置身外太空受綜觀效應的影響，去以創新的方式重新詮釋這些傳統工藝。

SPACE OUT
PROJECT

2016

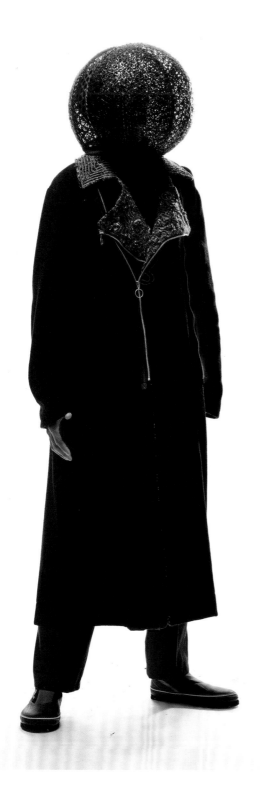

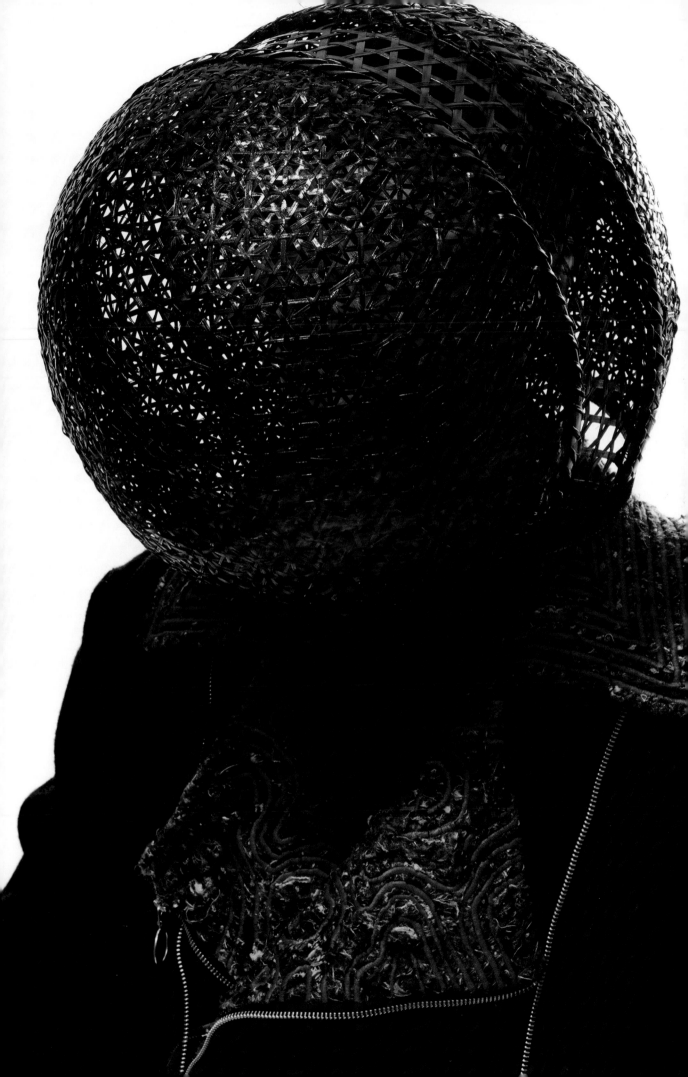

SYChen. Shoes

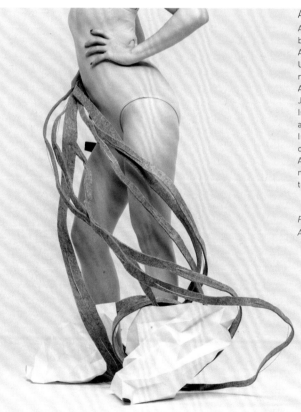

AUTHOR SUMMARY

Award-winning freelance footwear designer Sih Yu Chen is originally from Taiwan, but currently based in the UK.

After earning her Masters Degree in Design Innovation (Footwear) from De Montfort University, UK, in 2010, she began her career with Taiwan-based online footwear retailer Full Creator, where she was head of design and product development.

Among her freelance work, she has created designs for American footwear brand Justin.

In 2014, Sih Yu's work was selected for inclusion in Emerging Creativity in Asia Vol. 5, and was the only footwear designer to be chosen.

In 2015, she was the winner in both the women's footwear and men's footwear categories of the Taiwan Footwear Design Awards.

Also a writer and educator, Sih Yu is a regular columnist for Taipei-based lifestyle magazine Fliper, and created a popular footwear design course for online Taiwanese tutorial website Hahow.

Please describe yourself in a few words
Actions speak louder than words.

NATION /
TAIWAN

DESIGNER /
Sih Yu Chen

BRAND /
SYChen.Shoes

國家 /
台灣

設計師 /
陳思仔

品牌 /
SYChen.Shoes

創作者簡歷

2009 年獲台灣經濟部工業局公費留學資格赴英國取得碩士，返台後於線上女鞋品牌 Full Creator 擔任設計師。離開品牌後至今為自由接案獨立設計師，設計男鞋作品於 2014 年在美國最大鞋類商展 Magic(拉斯維加斯) 展出，2015 年獲台灣鞋類設計比賽女鞋組與男鞋組的雙首獎，2016 年移居海外，目前定居英國，現職獨立鞋類設計師與線上課程教育者；專欄寫作、演講、創作、線上課程為現階段職涯發展核心。

一句話形容自己
坐而言不如起而行

2017 Cloud

Origami is not only a type of art, but also a science. It brings me grand influence which undoubtedly has become my style in every design. This piece combines ideas of clouds and time.

摺紙它代表的是一種結構，它不僅是種生活藝術，更是種科學。我從時間裡看見自己過去學建築時建立的習慣，雖然我沒有完成那一段建築與空間的學位，但它帶給我的影響，卻是永遠的。雲與時間的流，讓我看見自己的命運。

雲

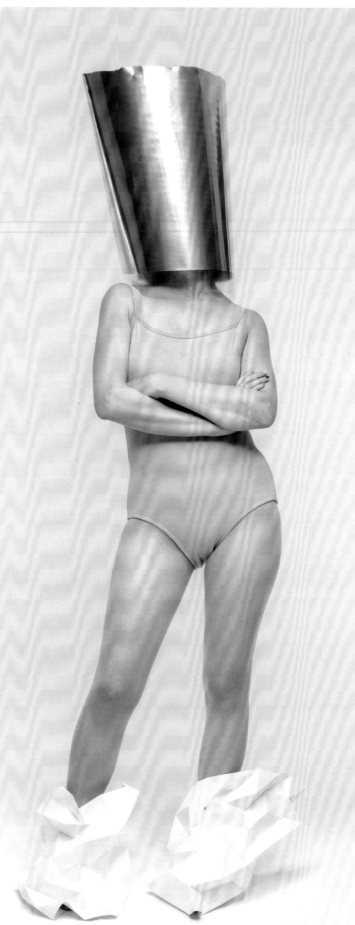

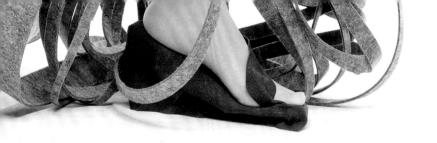

時　間

時間帶給我感悟，而命運讓我看見時間。我想用藝術的手法詮釋鞋類的結構，使它不僅僅是鞋子，而是我對時間與生命感悟的理解。這個系列有著我過去二十多歲時學習過建築與空間設計的深刻影響，結構主義的影子。除此之外，摺紙也是這個系列作品相當重要的一項元素，它既是種生活藝術，也是結構科學。時間將我帶回過去，反省與檢視自己；時間也帶我到了最接近現在的自己，看見我對結構的喜愛。最後，時間帶我看見 2016 年所發生過的所有事件，讓我檢視自己並且眺望自己所喜愛與渴望的未來。

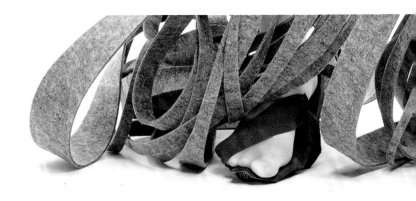

2017 Time

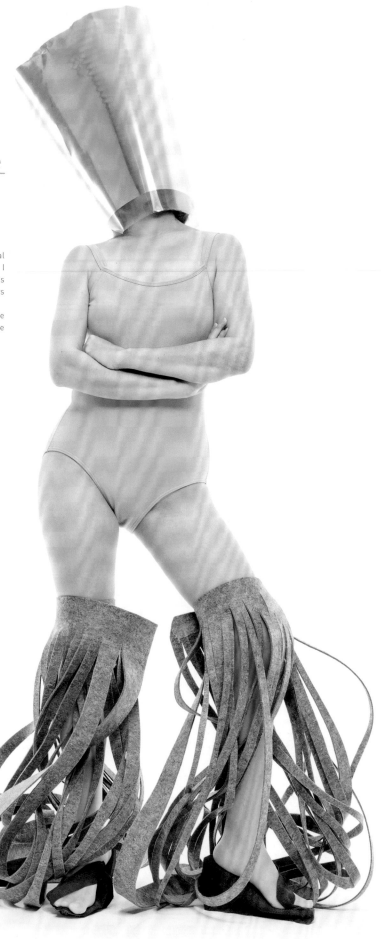

The collection is influenced by time. A number of personal events in 2016 have caused me to look back at my life, and I have become aware of the strong influence structuralism has had in my work since I studied interior architecture many years ago.

The objects I create emerge from manipulation of the material, and their origami-like forms, are how I present the structuralism inherent in my design style.

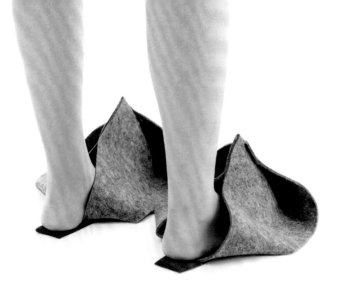

2017 Origami

Origami brings possibilities and feasibilities to different materials. If it is possible, find your maximum ability to do things.

摺紙讓我看見材料變化的許多可能性。我們每個人都應該探索自己的最大可能。

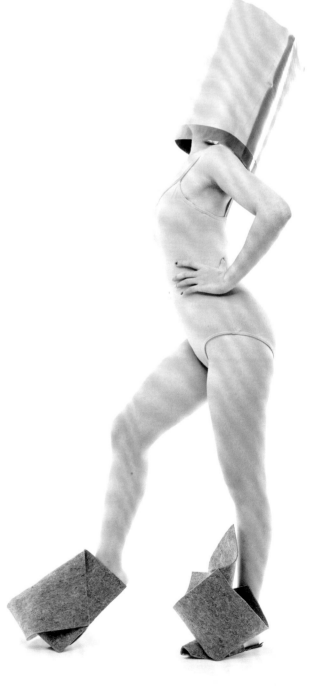

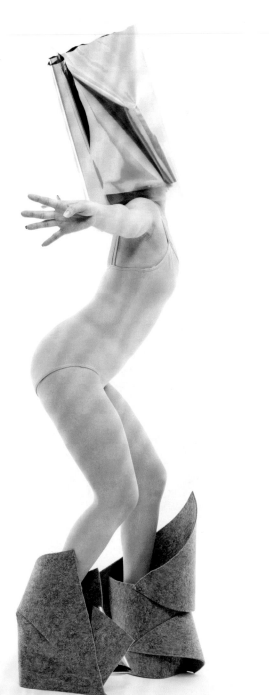

摺　紙

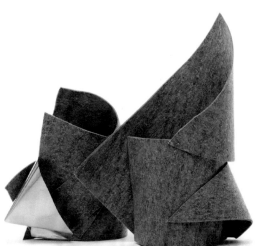

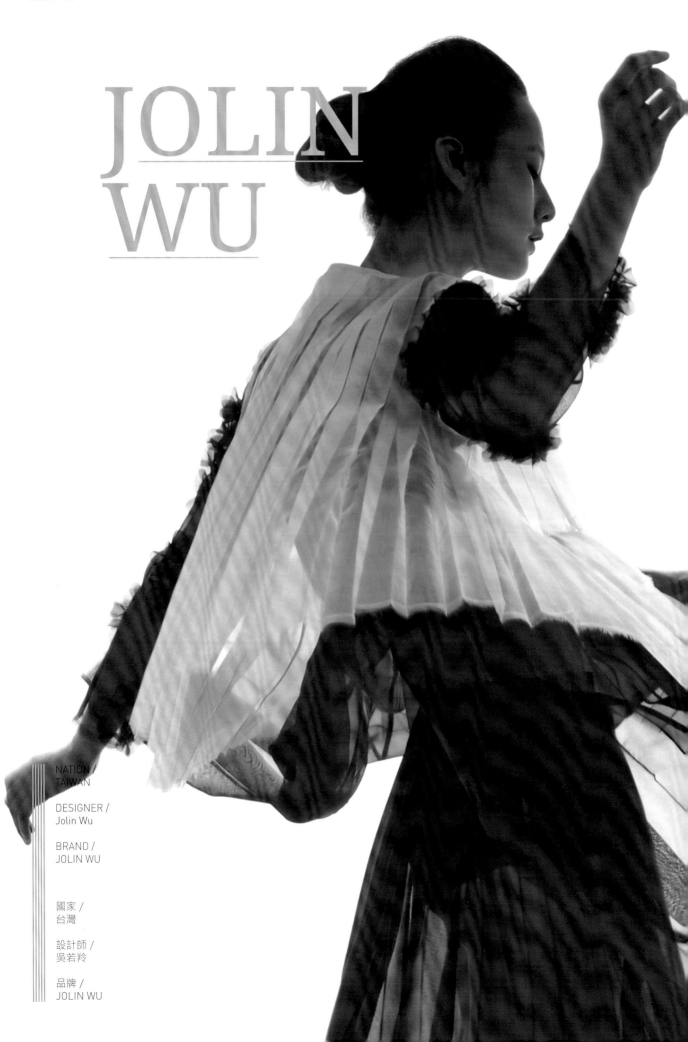

JOLIN
WU

NATION /
TAIWAN

DESIGNER /
Jolin Wu

BRAND /
JOLIN WU

國家 /
台灣

設計師 /
吳若羚

品牌 /
JOLIN WU

AUTHOR SUMMARY

A graduate of the Central Saint Martins College of Art and Design and the Royal College of Art in London, Jolin Wu studied fashion design womenwear as well as artistic creation. Since the establishment of her own brand in 2008, she has produced works that carry a sense of both rebellion and elegance, full of an artistic feeling rarely seen in fashion circles. Following a childlike and romantic design concept with hand-sewn details comparable to bespoke clothing, as well as conveying a cinematic-like poetic interpretation, her unique aesthetic approach is like a breath of fresh air in the industry.

Please describe yourself in a few words
Dreams, Depicting Designs. Using Design to Expand Dreams.

創作者簡歷
畢業於英國倫敦聖馬汀藝術學院、與皇家藝術學院,修習女裝設計與藝術創作。2008年成立品牌以來,作品叛逆優雅、充滿時尚圈少見的藝術感,童趣浪漫的設計巧思、媲美訂製服般精緻的手工縫製細節,以及如電影畫面般詩意的詮釋方式,其獨樹一幟的美學概念總是帶來令人耳目一新的感受。

一句話形容自己
夢想,描繪設計。利用設計擴展夢想

QANIK snow in the air, snow falling

2015

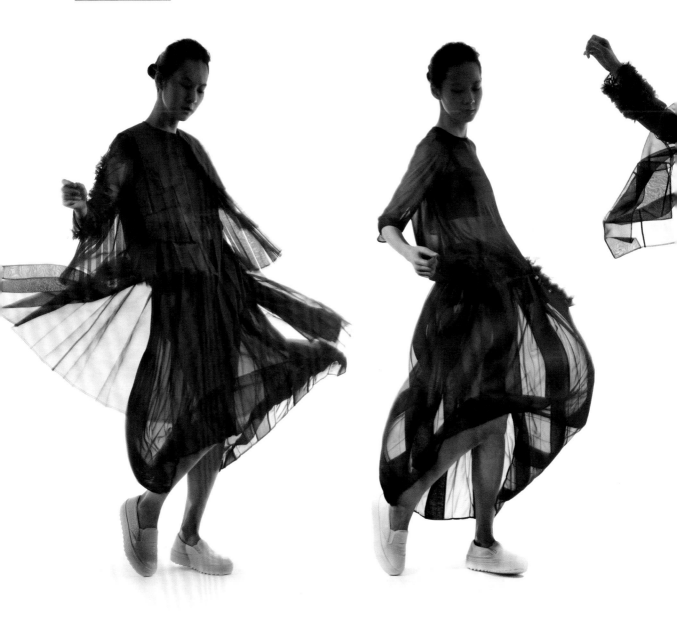

Snowflakes drift down. In the cold air, it's a world with no colors. Located in the arctic circle, Greenland, is a dreamland...

A 2015SS designer, Ruo-Ling Wu, was inspired by the word Qanik. Qanik in Eskimo word means the moment when snowflakes are drifting down. The current issue o climate change opens the conversation between fashion clothing and environment---polar circles are where this fashion season begins. Right after spring and summer the colorful seasons, here comes this world with no colors. It's like taking a flying vehicle to here---Organza, thin like a layer of ice, and light. The hand sewing piece are like drifting snow- flakes, and the different gauzy fabrics show layers. This piercingly cold yet opposing aesthetic brings you to the Northern part of the dreamland The original totem of Greenland also inspires designer Ruo-Ling Wu. Submarines, gingerbread man, and lightning are detailed in her hand sewing, which shows th youngness at heart, and it's the special romantic element in this season. In the 2015 spring and summer collection, there are 20 sets of tailor-made fashionable dress Besides the whole see-through style, the making process also had a breakthrough, such as such as three-dimensional sculpture-like pressure vest, and the seamles processing details that make the clothing almost reversible. This season is way more see-thorough than it has ever been, it's the Ruo-Ling Wu coolness and freshness. "There's a lot of conflicting elements in this season's design, but once you get into it, you'd be very surprised!"

This is what designer Ruo-Ling Wu wants to bring you---A wonderful journey.

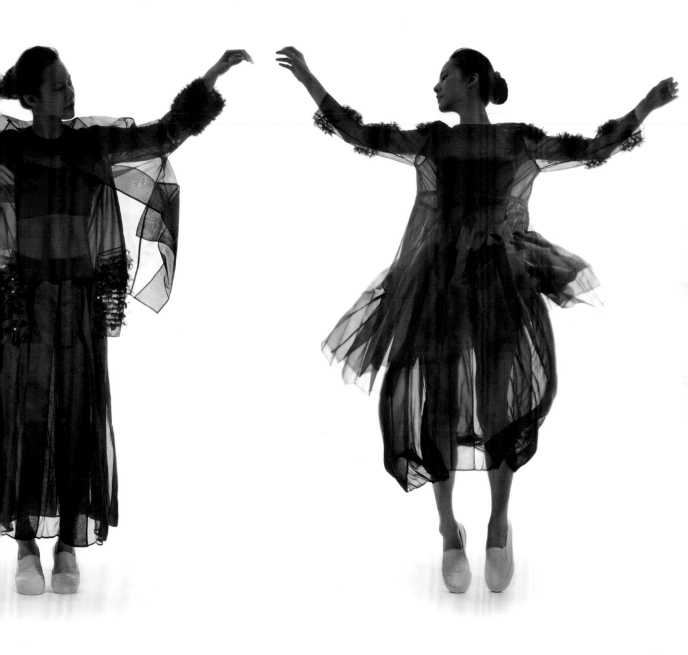

雪花飄灑落下，冷冽的空氣中，剎然一片低彩世界，位處極圈的格陵蘭島彷彿是幻境國度……
2015SS 設計師吳若羚以 Qanik 作為靈感來源，Qanik 是愛斯基摩語中形容：白茫雪花片片飄散揮灑落下的瞬間，在全球氣候現象的當今議題之下，首先開啟了時裝與環境的對話 ---- 以極圈探索作為本季的時裝入口，在繽紛的春夏季節中軋然出現一片低彩世界，彷彿乘著飛行器來到了幻境國度 --- 宛如薄冰的烏干紗、穿透飄動的輕盈線條、飄落雪片般立體的手工縫片、運用不同質感的薄紗材質來展現通透的層次，透過這樣的冷冽衝突美學，帶您一起探索北國幻境。而格陵蘭島的原始圖騰，也啟發設計師吳若羚重新詮釋，將潛水艇、薑餅人、閃電等符號隱藏在每個手工縫製的細節中，展現其富有童心的一面，成為本季獨有的浪漫元素。展出的 2015 春夏系列中，以訂製服規格打造的 20 套全新時裝，除了追求整體風格的透明感，在製作手法上也有重大突破，如立體雕塑般的壓褶背心，幾乎可以雙面穿的無接縫製作處理細節，讓本季所追求的通透感更加無敵，為炎熱的春夏季，注入一股吳若羚式的清涼。「這一系列在設計上，好像加進許多不同的衝突元素，但你一旦進入，就會有意想不到的發現！」這是設計師吳若羚所帶來 --- 一段美妙的探索旅程！

QANIK snow in the air, snow falling

2015

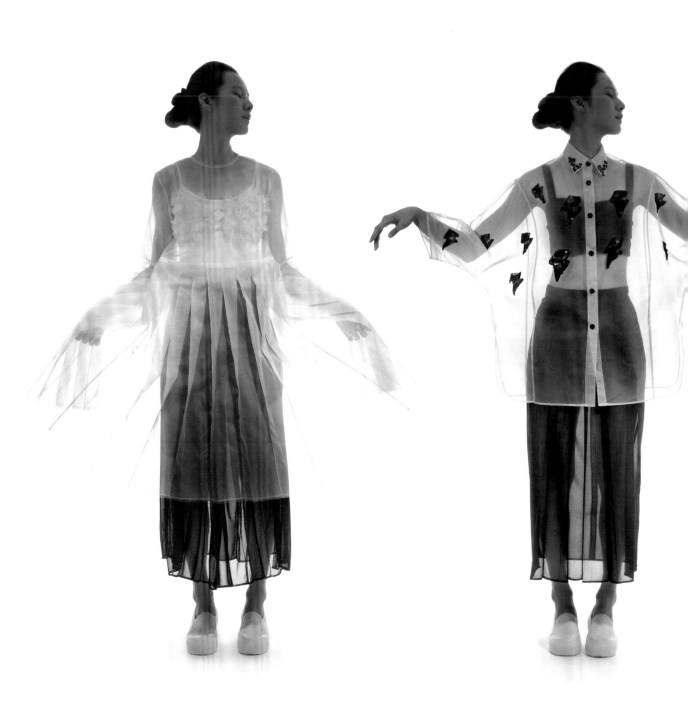

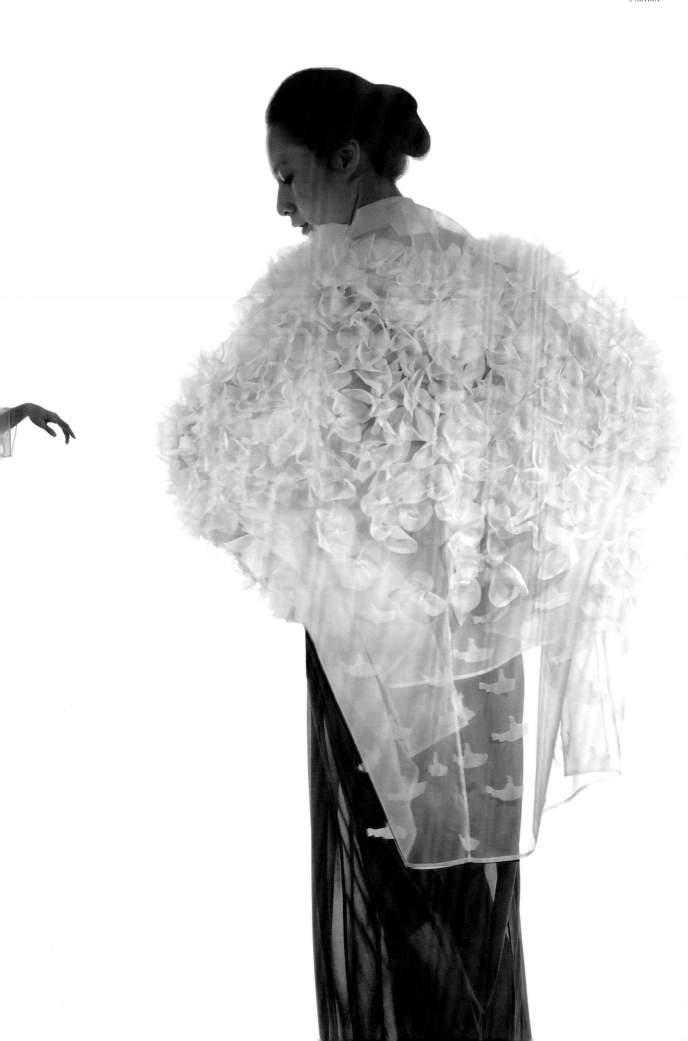

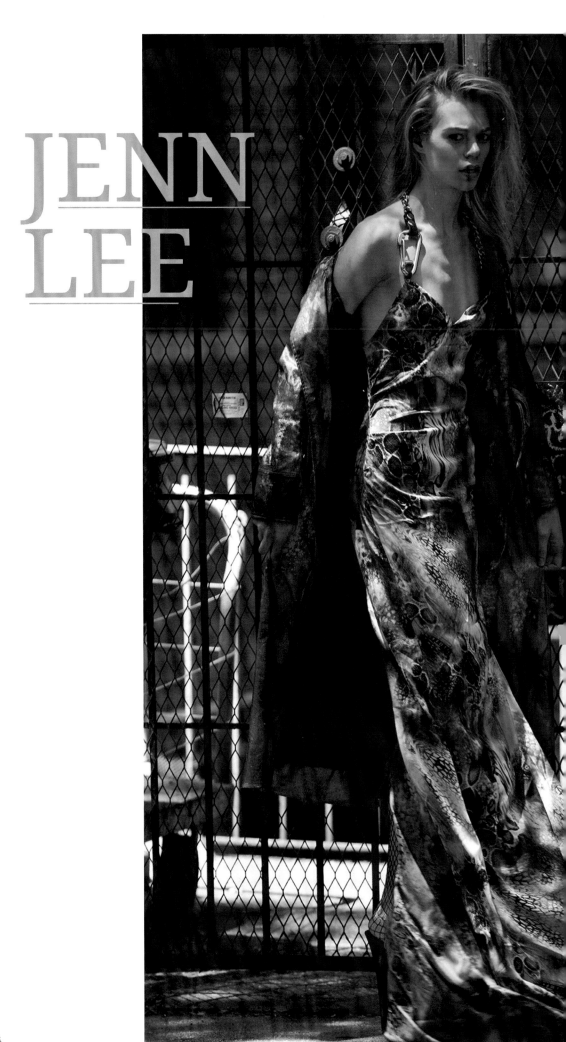

JENN LEE

NATION /
TAIWAN

DESIGNER /
Jenn Lee

BRAND /
JENN LEE

國家 /
台灣

設計師 /
李維錚

品牌 /
JENN LEE

AUTHOR SUMMARY

Freedom defines the ethos and attitude underpinning Jenn Lee's work. Incorporating both strong and delicate deconstructionist features, JENN LEE designs showcase an independent and uninhibited modern aesthetic via a multitude of global influences from the worlds of art and fashion. These include French visual art, New York hip-hop dance, London sound art, Taiwanese hand-dye and visual/tattoo art.

Designer Jenn is a graduate of University of the Arts London. Before starting JENN LEE, she interned at Alexander McQueen under the Gucci Group. In 2015 Jenn was invited to exhibit the JENN LEE 2016SS collection at the Poland contemporary art gallery. The related 2017SS film had been chosen for the Berlin Proxy Film Festival.

The JENN LEE label uses unique and impactful imagery inspired by Jenn's exploration of the world. JENN LEE designs exist as an expression of a free and independent soul.

Please describe yourself in a few words
" Fashion fade, style is eternal." - Yves Saint Laurent

創作者簡歷
品牌 JENN LEE 以「自由」定義作品態度,善用拼貼與解構等非傳統手法呈現現代女性特有的浪漫與不羈。JENN LEE 的服裝跨足時尚與藝術,讓時裝擁有更深層的故事與藝術性。主理人李維錚 Jenn,畢業於倫敦藝術大學,曾任職 Alexander Mcqueen 與 Felicity Brown。 Jenn 追求時尚的多變性,藉由旅行探索心靈,延伸自我的發展性,多觸角與不同國家創意工作者合作;法國影像藝術家 / 紐約 hip hop 舞者 / 倫敦 trip hop 音樂人 / 台灣手染藝術家、視覺藝術家與刺青工作者等。Jenn 在旅居柏林時,品牌 JENN LEE 服飾作品受邀與波蘭當代藝術家共同創作聯展,針對探討當代社會議題;17 年春夏之服裝發表影像,也榮譽獲選柏林國際影展,將於 2017 年九月在德國首映。
JENN LEE 獨特的想像源自于對生命力與世界的好奇探索,她的設計存在于獨立女性。

一句話形容自己
「時尚易逝,風格永存。」- Yves Saint Laurent

Photographer Dennis Fei

Concentrationcamp-Freedom
2016

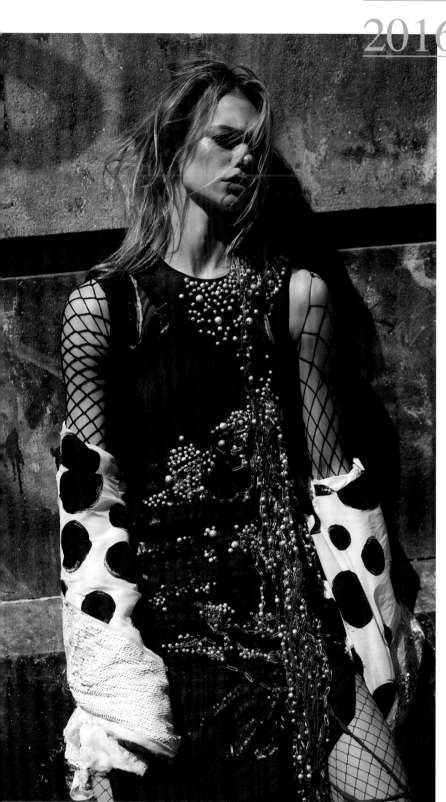

Designer Jenn Lee visited Nazi concentration camps when she was in Germa- ny, and it had a huge impact on her. After she got back, she made a series of clothing, and made it a connection to make conversations and inquiries. She tries to find a young voice in this generation. Freedom. Are we in a concen- tration camp in this generation?

During the Second World War in Germany, Jews were being persecuted in Nazi concentration camps. Fashion clothing artists speculate the scenes from then by photos, videos, and the camps' ruins, and they try to get the idea of blood, bodies, and limited minds.

創作者 Jenn Lee，旅居德國拜訪了二戰時期的納粹集中營，深受衝擊。回國後製作了一系列的服裝，並與現代舞舞團，以服裝做為媒介進行對話與探詢。

試圖尋找年輕一代在這時代的聲音。自由。我們存在當代的集中營嗎？德國二戰時期，迫害猶太人的集中營，服裝藝術創作者透過照片、影片、集中營遺址中思索著那時代的場景，並從中擷取如血液、殘破的身軀、被束縛的身心等意象創作。

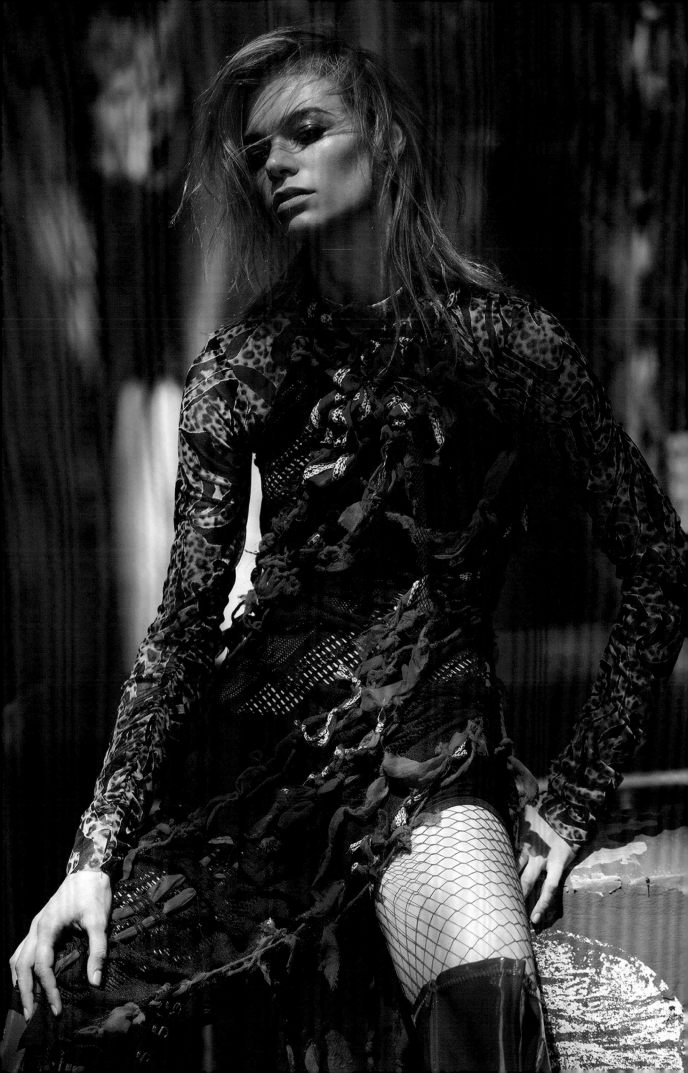

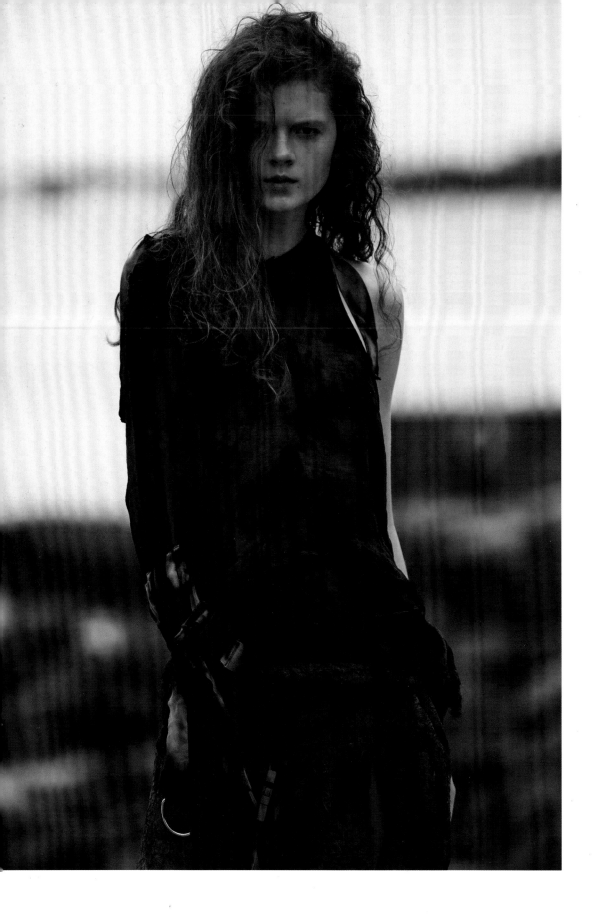

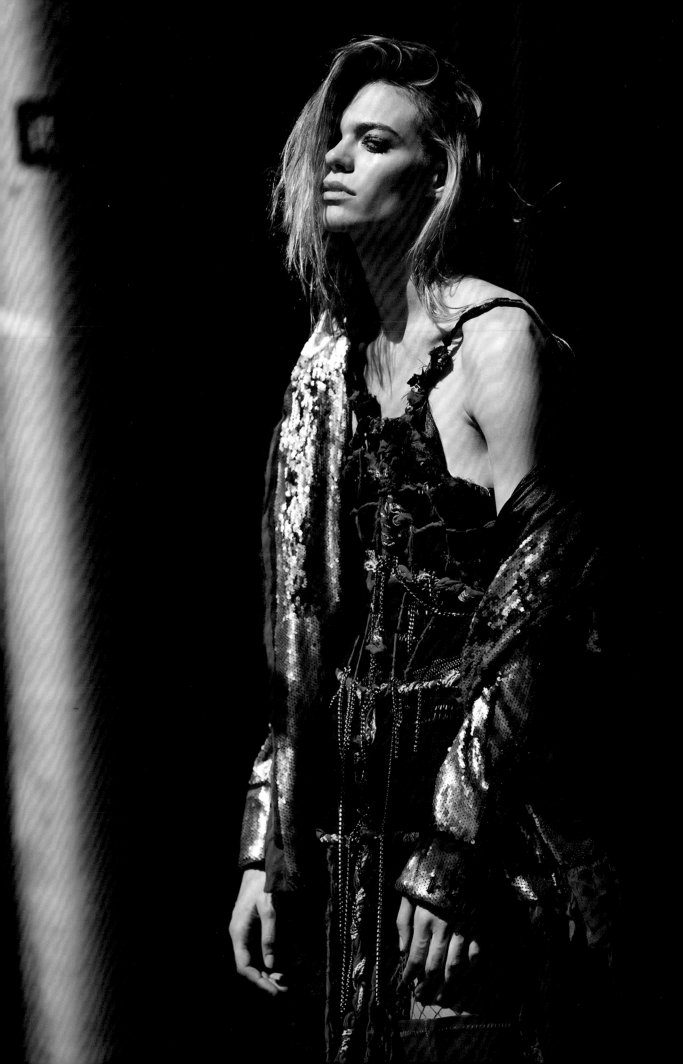

Freedom
2015

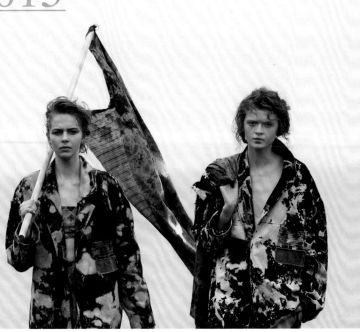
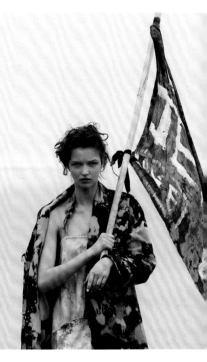

"Freedom" is the main point of designing, it's about love, peace, and vitality. Using twisted and deconstructed methods, and the color of soil and sunset as the basic color tone. Collaborating with Taiwanese tie dye artist and Tai- wanese tattoo artist, and making every work unique by combining these methods.

In the summer of 2014, she was at the Glastonbury music festival in England, walking in the rain. She was alone and she thought to herself: "If my friends were here, it'd be way more fun! I want to design unique clothing just for them and take them with me!" After she got back, she started to design cloth- ing for her 21 friends-2016 spring & summer.

以「自由」當作創作主軸，訴說愛、和平與生命力。以扭曲與解構的破碎手法，使用土地與夕陽的顏色為基本色調，與台灣手染藝術家與台灣紋身藝術家合作，使用極其費工僅能獨立製作的手工雜染技巧與手繪製作每件作品。

2014 年夏天的英國 Glastonbury 音樂祭，她踩著雨鞋，一個人走在泥濘中，寂寞的她內心唯一想法：「如果我的朋友能夠在身邊，一定更快樂！我想為你們製作獨一無二的服裝並且帶上你們！」回國後，Jenn 便開始為了這二十一位好朋友定製屬於他們個人特質的服飾 - 2016 春夏。

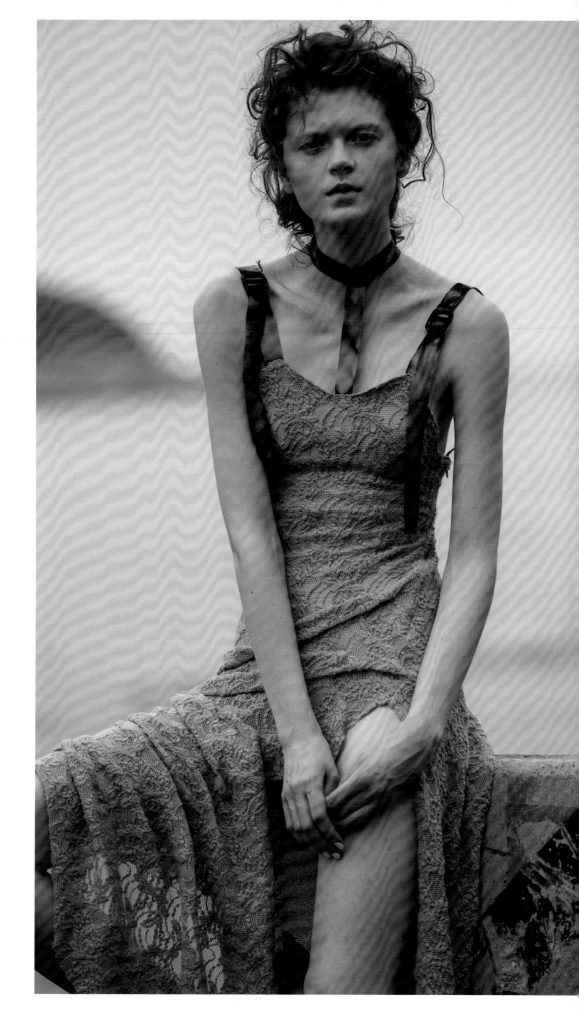

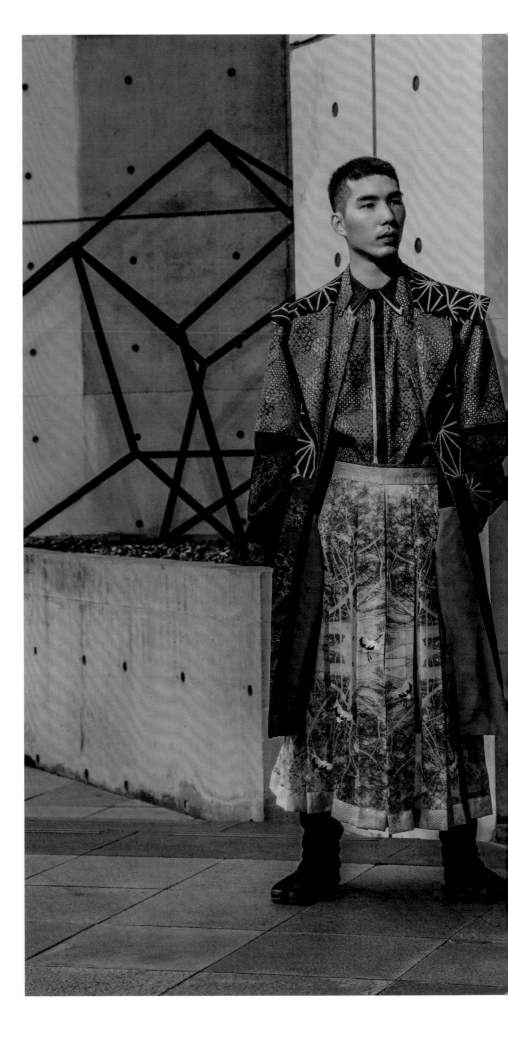

NATION /
TAIWAN

DESIGNER /
Lin Yang-Hong

國家 /
台灣

設計師 /
林洋弘

n
ang-Hong

AUTHOR SUMMARY

The author got into the field of drawing and art since he was little, so he got very interested in art and culture activity. He makes good use of his love for art and culture. He's good at using colors, patterns and multiple media in designing clothing. Also, the author loves to travel, and explore local culture, history, and art. He often presents the experience during his trips in his works, which makes his style very unique.

Please describe yourself in a few words
A fashion designer who loves art and culture, and traveling.

創作者簡歷

創作者自小接觸繪畫與美術對於藝文充滿濃厚的興趣，在跨足服裝設計領域後延續自己對於藝術與人文的喜愛，擅長將色彩、印花圖像與多元媒材應用的形式展現於服裝創作中，同時創作者熱愛旅行，喜歡藉由旅行去探索地方的文化、歷史與藝術，也時常將旅行經驗中感受異國文化的過程轉換為設計要素呈現於作品，進而發展出自己特有富含人文美學意境的個人創作風格。

一句話形容自己

熱愛旅行與藝術人文的時尚創作者

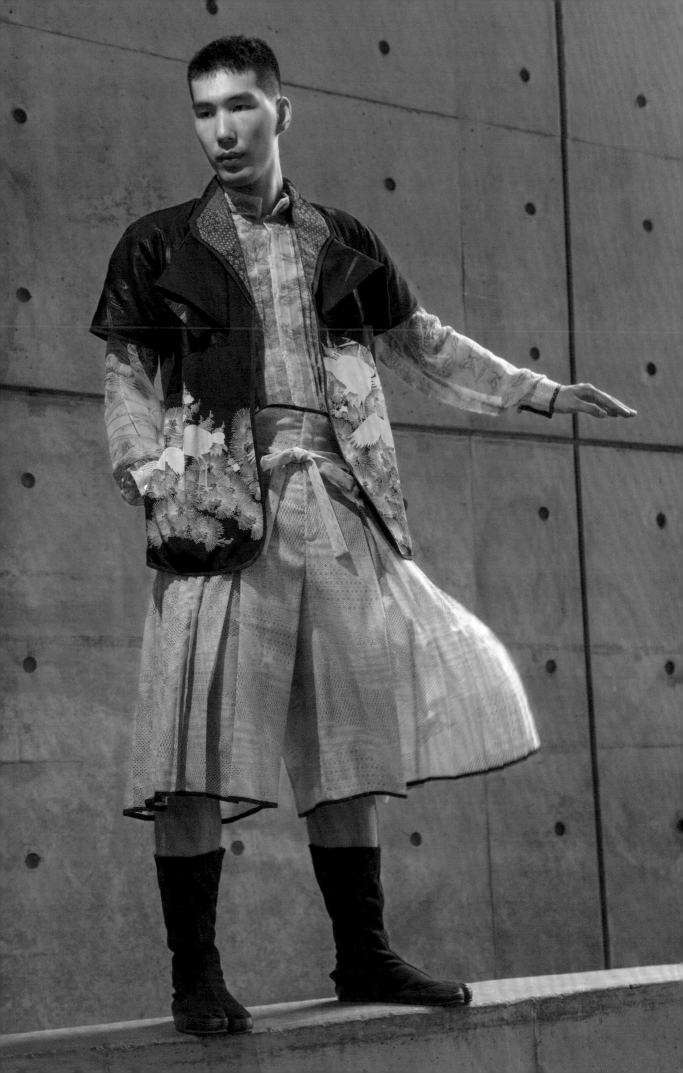

Memory of Kyoto

2016

This collection focus on designer's experience during the journey in Kyoto, which is the main inspiration of the fashion design works. The collection use the visual design elements to elaborate designer's personal emotion in exotic journey, and utilize the narrative technique of metaphor characters to explain personal emotions in various stages, while transforming the trait of exotic cultures into the design concepts. The collection capture the design concept through designer's travel experience, and transform the design concept into design planning. By the way, express the fusion of new and old, unisex style and the combination of different materials.

設計系列以創作者赴日本京都旅行的體驗為靈感，從旅行經驗中自己感受日本文化之特質延伸出核心創作精神、設計風格及表現技法，藉此詮釋古都多元文化兼容並蓄的人文情景。

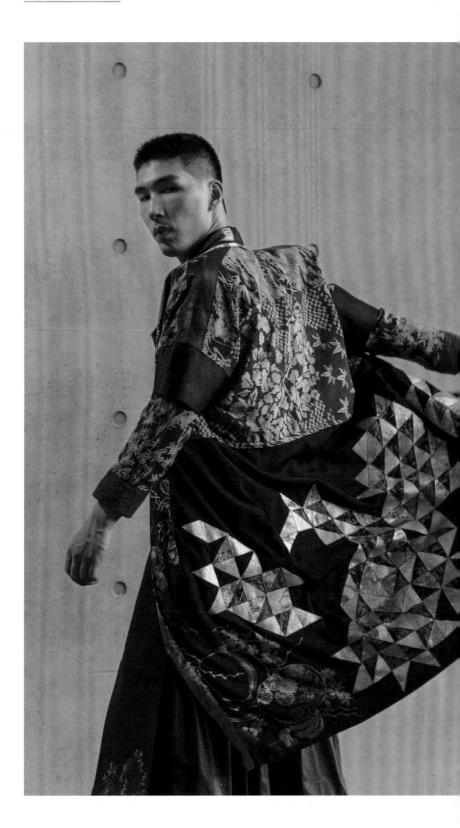

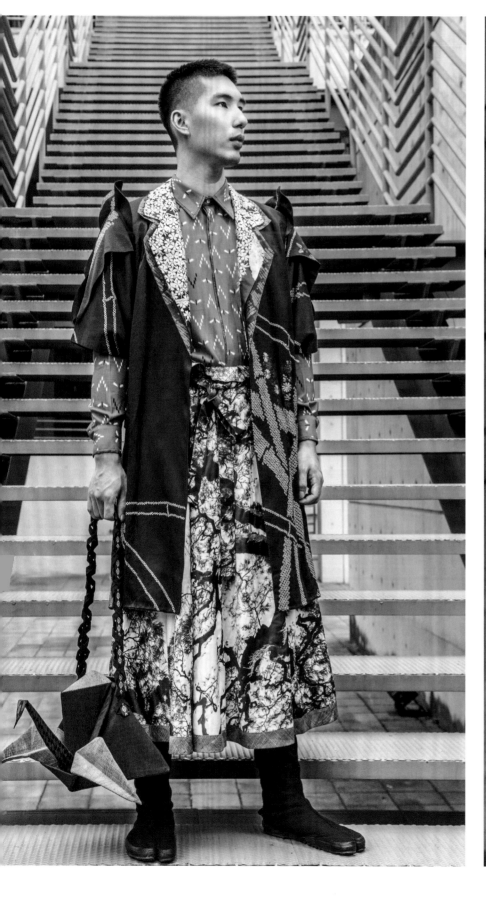

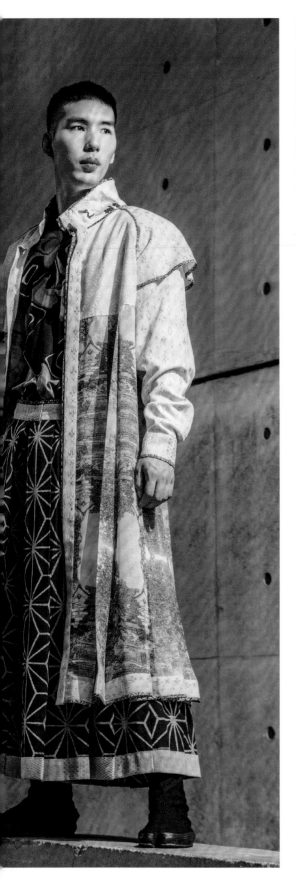

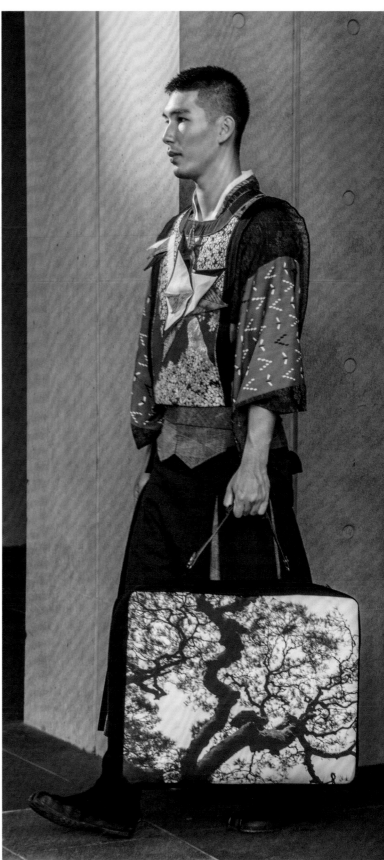

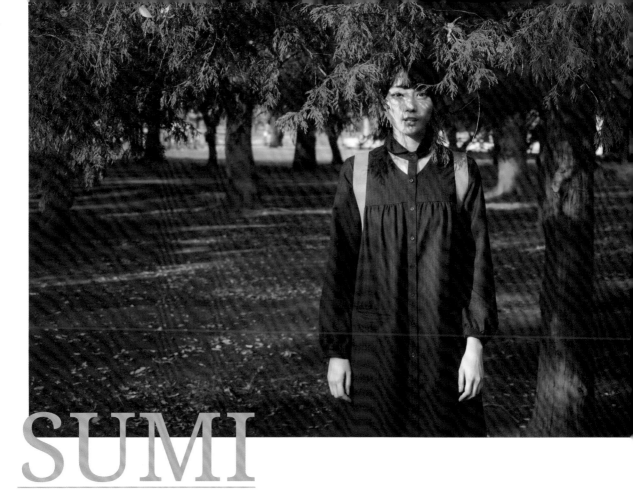

SUMI

AUTHOR SUMMARY

Haru, who came from Taiwan and graduated in Fine Arts.
Found his way into fashion industry after his graduation and has been a chief designer for servel international well known brand names. Most designed goods have been sold in UK, France, Italy, Australia, USA, Japan, China, and Taiwan.
During 2013-2016, who was assisgned to one of designers for Taiwan Textile Extension Union. In 2015, who was invited to be the speaker for both Pinkoi seminars and Ministry of Culture in Taiwan.
Currently, focused as chief designer and management for "SUMI", a Taiwan based brand name.
In every steps, from image, concept, literal, development, design, material picking, molding, products shooting, and management are from the bottom of heart, that belived in a beauty experiences.
Haru, who created its own personality and style by using both fiber and his heart.

"Beauty will withered, but soul will not"

Please describe yourself in a few words
When I have an idea, I plan and implement.

NATION /
TAIWAN

DESIGNER /
Lee Haru

BRAND /
SUMI

國家 /
台灣

設計師 /
李向明

品牌 /
SUMI

創作者簡歷
畢業即進入時尚產業，曾擔任多個跨國服飾、鞋包品牌設計師，並經歷多個國際品牌亞太地區品牌操盤手，設計商品曾販售於英國、法國、義大利、澳洲、美國、日本、中國、台灣。 2013-2016 為台灣紡拓會聯盟設計師，2015 獲邀擔任 Pinkoi 設計師講座主講者 ，文化部青創職人專訪等。目前專心投入於台灣自有品牌 SUMI 設計師及品牌經營。對服裝的堅持體現在每個環節上，從形象概念、企画、文字、研究開發、設計、選料、打版製作、商品拍攝、至幕後品管等，並相信美麗的體驗，是來自於內心。用纖維與內心的聯結，建構屬於自己的個性。

「美麗會凋零，靈魂不會。」

一句話形容自己
有了想法就會去計劃執行。

Windsor
2016

This is a relationship between soul, body, and the outside world. Cutout design is like opening a window, it lets out souls, and feels harmonious.

這是一個靈魂,身體與外界的關係,局部鏤空的造型就像是開了一扇扇小窗,在解放靈魂的過程中,平衡與和諧。

◀　溫莎公爵鏤空洋裝

Believer
2015

The whole design style is simple and neat, it shows modern women's reck- lessness at workplace.
Yet the palatial folding cuffs show the elegance.

整體簡約俐落設計表現都會女性於職場上率性俐落的一面,宮廷抓摺袖片卻又不失女人原有的優雅柔媚。

▼　信仰長版洋裝

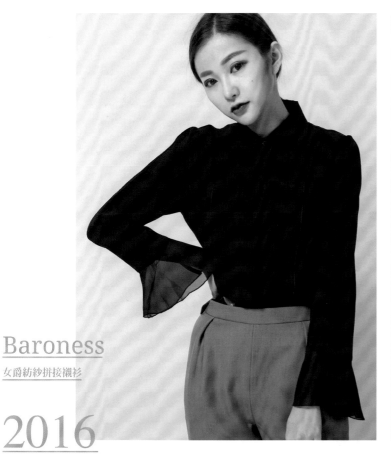

Baroness
女爵紡紗拼接襯衫

2016

Make soul into Jazz music, and dance to it.
Splice details together as the design base, just like every dancing note in jazz music. Penetrating texture goes deep to soul, pleats and bord edges intertwine, making more melodies.

用靈魂譜出爵士樂曲,將身體美妙的姿態舞動搖擺。各種拼接的細節做為設計基底,彷彿爵士樂裡每一個跳動的音符,透視的質感沁入靈魂深處,褶子與細微的收邊透過光影交織出更多旋律。

Experiment
2015

Simple lines present the clothing's outline. Depict with souls, and converse with clothing. From an experimenter's angle, curiously interprets the strange world.

簡單的局部線條襯出衣服的輪廓，用靈魂來描述，用衣服來對話，以一種實驗者的角度，好奇地詮釋陌生的世界。

實驗者無袖洋裝

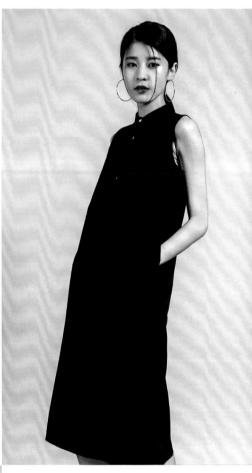

Outer Space
Galaxy
2015

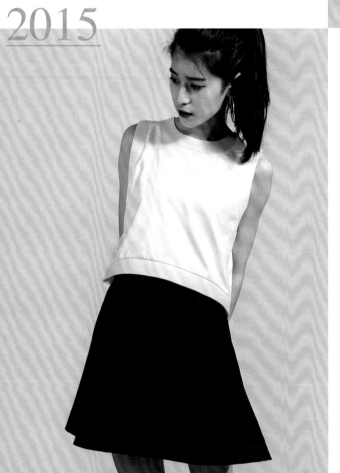

Simple lines splice design makes the sample has implicit changes. The sample is shorter in the front, and longer at the back, which goes with the scuba material, makes the style unique and layered.

簡約線條拼接設計，讓版型有較含蓄的變化，前短後長版型搭配特殊太空棉材質的運用帶出設計款式層次。

Harmonizing with the scuba material, it mainly uses simple lines and unique materials to make the whole style extensive.

與太空異材質背心相互呼應，主要以簡單線條及異材質拼接的運用使整體效果豐富。

太空異材質背心
星系異材質波浪短裙

Truth
2016

Simple lines flatter figure, and the see-through material is stylish and elegant, which also makes the whole style looks layered.

修身簡約線條勾勒，透膚異材質拼接讓整體設計個性中略帶女人柔媚的感覺，也使造型更有層次感。

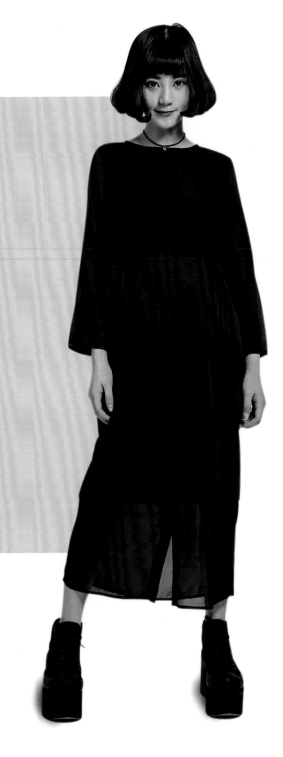

真理異材質剪接洋裝

HOMME VAN LAB

AUTHOR SUMMARY

HOMME VAN LAB was founded when the Design Director Kilin Chen was studying at ECOLE DE LA CHAMBRE SYNDICALE DE LA COUTURE PARISIENNE. The brand concept is to do something romantic with the spirit of science, combine the precise calculation of ergonomics and the French draping with the narrative printing creations. The works in every season are the outcome of experiments of philosophy and art, which gives fashion read- able cultural depth.

Since September 2014, HOMME VAN LAB participates in the exhibition of the Fashion Week de Paris regularly, and was announced on the official agenda for consecutive three seasons.

2015 Received Brand Award of Media Attention in China

2016 Was the founding member of Professional Committee of Haute Couture in China.

Appointed Ambassador of Taiwan in 2017.

Please describe yourself in a few words
Work takes all my romantic ideas, and the rest of rationality is used to cope with the adventurers in daily life.

NATION /
TAIWAN

DESIGNER /
Kilin Chen

BRAND /
KILIN COUTURE
HOMME VAN LAB

國家 /
台灣

設計師 /
張暘

品牌 /
KILIN COUTURE
HOMME VAN LAB

創作者簡歷

HOMME VAN LAB 創立於設計總監張暘 Kilin Chen 在巴黎製衣公會就讀期間，品牌的理念是以科學的精神做浪漫的事，將人體工學的精密計算結合法式立裁版型與富故事性的印花創作，每一季都是哲與藝的實驗，賦予時裝可被閱讀的文化深度。

HOMME VAN LAB 從 2014 年 9 月起，固定參與巴黎時裝週的展出，並且連續三季在官方活動日程中登出。

2015 年獲得中國媒體關注獎品牌。

2016 年成為中國高級訂製服專業委員會創始會員之一。

並於 2017 年授任台灣大使。

一句話形容自己

將所有浪漫情懷給了工作，剩下的所有理性面對日常生活的冒險者。

Wenchen: Transnational Love Trilogy I: Last night n Chang-an

2015

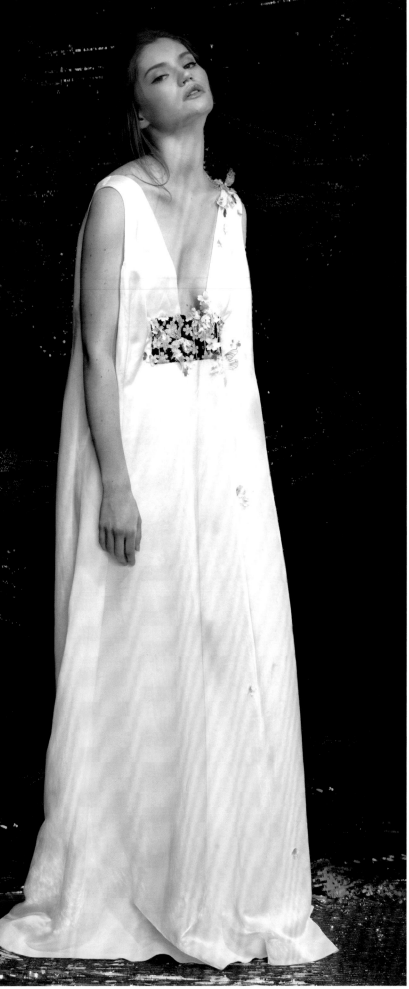

n the 7th Century AD, a golden time of Tang dynasty, Princess Wencheng, who was only 18 years old, married to the King of Tibetan Empire, Songtsän Gampo, for the stability of southeast and western national boundaries. We have no chance to know what the princess's feeling and her name due to no existing records n any history books; however, we can image that she could only picture the place where her future husband, people and life will be from the words of the wedding envoys when she was on her journey across mountains nd lakes to the distant plateau country, an unknown and different world with unfamiliar figures and landscapes far from her hometown. 2016 Spring/ and Summer women's collection is the first story of Transnational Love Trilogy between eastern and western nations inspired by Princess Wencheng's peace marriage of state to Tibetan Empire n Tang dynasty. An interracial marriage brings out an integration of religion, art and culture, and this legacy and influence lives on for every courageous woman being so brave to across cities of another foreign country for love. In this season, in addition to use natural silk, linen and extra thin wool, HOMME VAN LAB also adopts fiber abrics of Canadian pine needles, which is a natural fiber abrics with silk texture, functions of moisture absorption and sweat discharge as well as no distortion in wash. With respect to the process of realizing tailor- ing, the cut comprising of knots, gold foil printing, 99 pure gold printing and simple & natural cut creates such a uniquely uxurious and elegant style.

公元七世紀，大唐盛世，年僅十八歲的文成公主為了帝國東南邊疆的安定和親西域，嫁給當時的吐蕃國王 - 松贊干布。我們無法從現存任何一本史書上得知這位公主的名字與出嫁時的心境。穿越群山湖泊，來到遙遠高原上的國度，對於文成公主而言，那裏的人物、風景是個未知的異世界，只能從迎親使臣的隻字片語中去猜想他未來的夫婿、子民與他們所生活的地方。2016 年春夏女裝系列是一個關於跨越東西方的愛情三部曲中的首部曲，靈感來自於唐朝文成公主的和親吐蕃的歷史，一場異族的婚姻激盪出一次宗教、藝術與文化的東西融合。而這段歷史在現今各個國家的不同角落持續上演，所有為愛飄洋過海的異國女子，一次勇敢的旅程孕育一座穿越的城。HOMME VAN LAB 這一季除了選用天然的真絲、麻與超薄羊毛外，還運用了加拿大松樹針葉纖維布料，這種特殊天然布料具有絲的質感和吸濕排汗的功能外，也可以水洗不變形。而在剪裁工藝上，結合燙金印花與 999 純金印花與簡單大方的剪裁創造出華麗而優雅的獨特風格。

文成：愛的越世界 I - 長安的最後一夜

The man she loves

2015

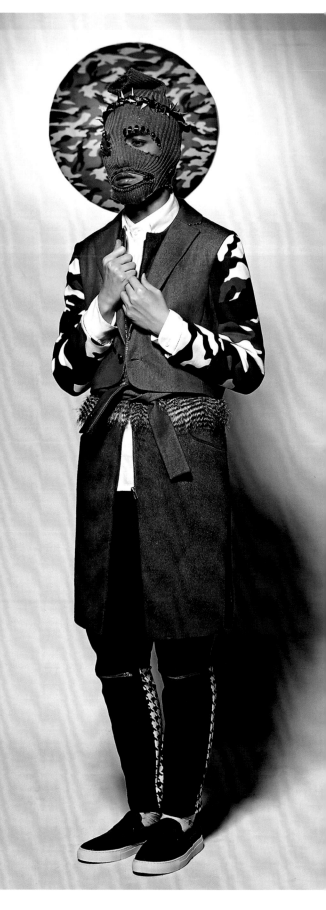

她的男人

這世間總有如此女子，為愛而生，為愛痴狂，彷若虔誠的信徒將她的
情人她的男人作為唯一真神放在心中的聖殿膜拜。男子所有的人性醜
惡在她眼中都是神性光輝的展現，求主垂憐，她是如此盲目失去了自
己，她永遠不會明白，神未死是由於朝聖者堅定信念的餵養。所以，
是怎樣的男子如此幸運或不幸戴上荊棘冠冕讓一女子託付一切眾生的
喜樂哀愁？我們在這一季秋冬男裝系列要告訴你的故事。這是一個信
仰者看見浪漫，無神論者覺得諷刺的故事。2015-16 秋冬的男裝系列，
運用不同材質布料的拼貼象徵人性與神性，沉著冷靜與衝動冒險，成
熟及幼稚，勇敢和懦弱的衝突，除此之外，也在每一件服裝的表層與
內層選用不同的顏色或印花，表現男主角樣貌在情人眼裡和自我認知
的不同與落差。

There is always been one woman in the world, she wasonly born
for Love. Man is her heart,Her unique path,the true belief among
the other things ... She would live with her passion named love that
seems to be a journey through the sacred temple, She glorified men's
humility unconditionally as those followers in the religion. How blind
this woman could be to lose herself for man in the life path? She
would never understand why... there is one god live is due to pilgrim's
piety . who is the lucky person that could be worship in her love palace
? That's the story we want to tell you in our 15-16 A/W Mens- wear
collection . In this series, we choose different fabrics to symbolize the
conflict, between divinity and humanity; self-possession and impulse;
mature and childish ;brave and coward.

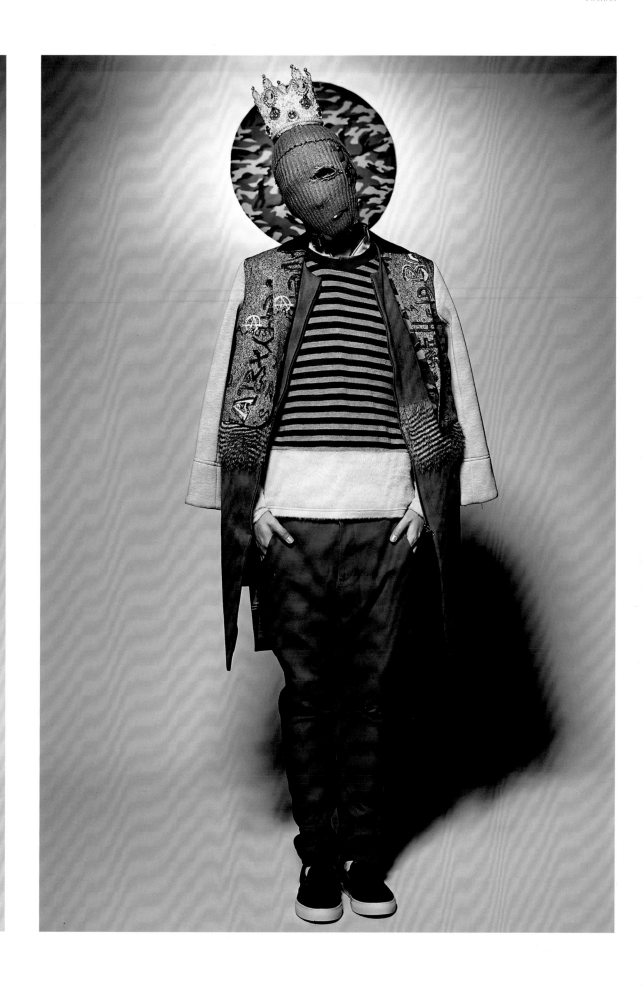

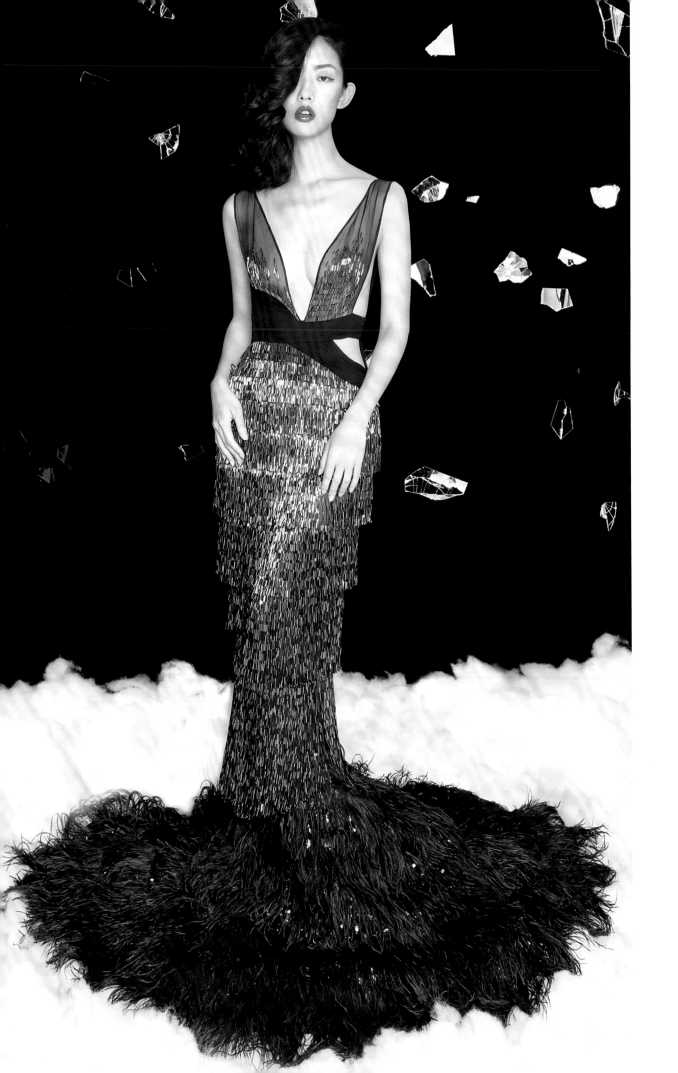

Galaxy Suite no.1:
Silence Nocturne

2016

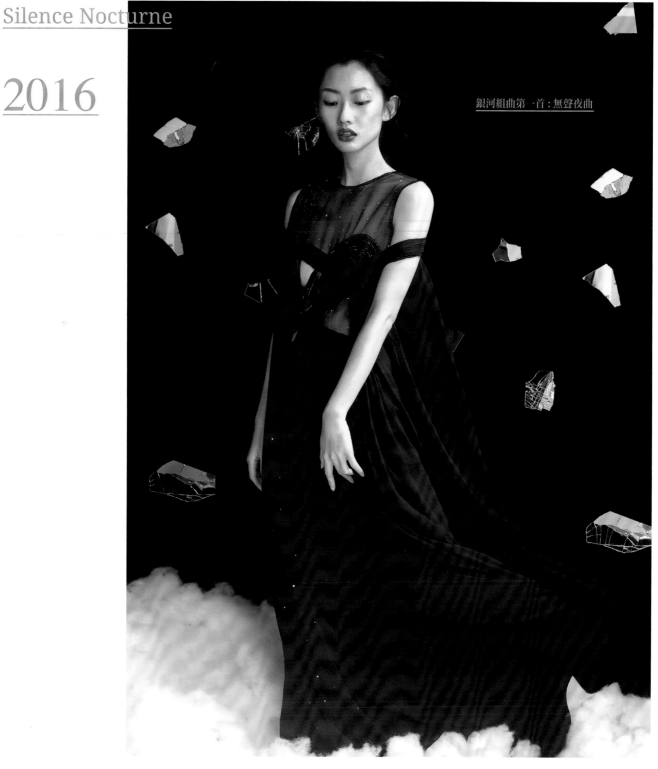

銀河組曲第 一首：無聲夜曲

Tong Yang-Tze believes that a city has a responsibility to continually enhance its cultural and aesthetic standing and, to this end, hopes to use the art of calligraphy to realize life's possibilities. For this exhibition, Tong has chosen 20 pieces from her Silent Music series. Working hand-in-hand with fashion designer Kilin Chen, she imbues the exhibition with her calligraphy's energy, rhythm and attitude. The result is that the calligraphic form becomes readily accessible—drawing in the public who come for a closer look in appreciation of the beauty and historical heritage of each stroke.

為書法編織出最美麗的想像，每一道筆觸與線條都是一顆行星天體運行的軌跡，在《無聲的樂章》的字裡行間觀想更高宇宙的存在，從墨跡銀河中聽到星星 說話的聲音。融合立體裁斜 (bias cut) 與殘繞的高級訂製服裝作技法，及手工珠 縫刺繡將董陽孜的書法線條幻化成銀河星途，交織出一篇關於仲夏夜星空的新樂章。

My Lover, my poem, and me

2017

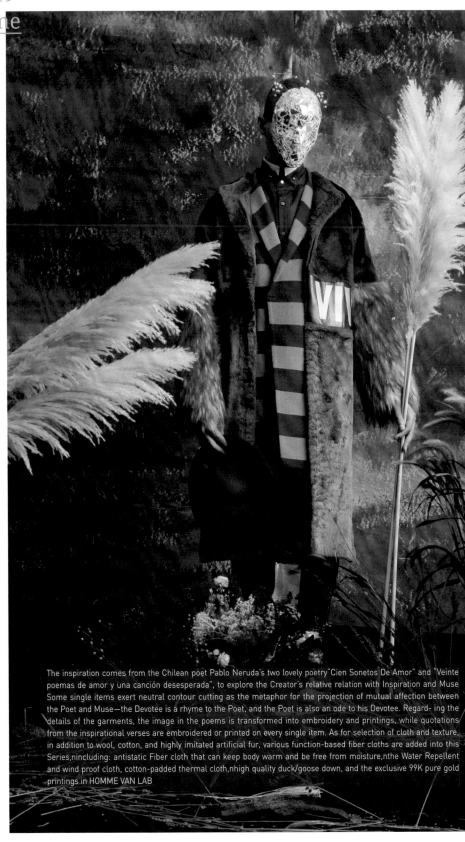

The inspiration comes from the Chilean poet Pablo Neruda's two lovely poetry"Cien Sonetos De Amor" and "Veinte poemas de amor y una canción desesperada", to explore the Creator's relative relation with Inspiration and Muse Some single items exert neutral contour cutting as the metaphor for the projection of mutual affection between the Poet and Muse—the Devotee is a rhyme to the Poet, and the Poet is also an ode to his Devotee. Regard- ing the details of the garments, the image in the poems is transformed into embroidery and printings, while quotations from the inspirational verses are embroidered or printed on every single item. As for selection of cloth and texture, in addition to wool, cotton, and highly imitated artificial fur, various function-based fiber cloths are added into this Series,nincluding: antistatic Fiber cloth that can keep body warm and be free from moisture,nthe Water Repellent and wind proof cloth, cotton-padded thermal cloth,nhigh quality duck/goose down, and the exclusive 99K pure gold printings in HOMME VAN LAB

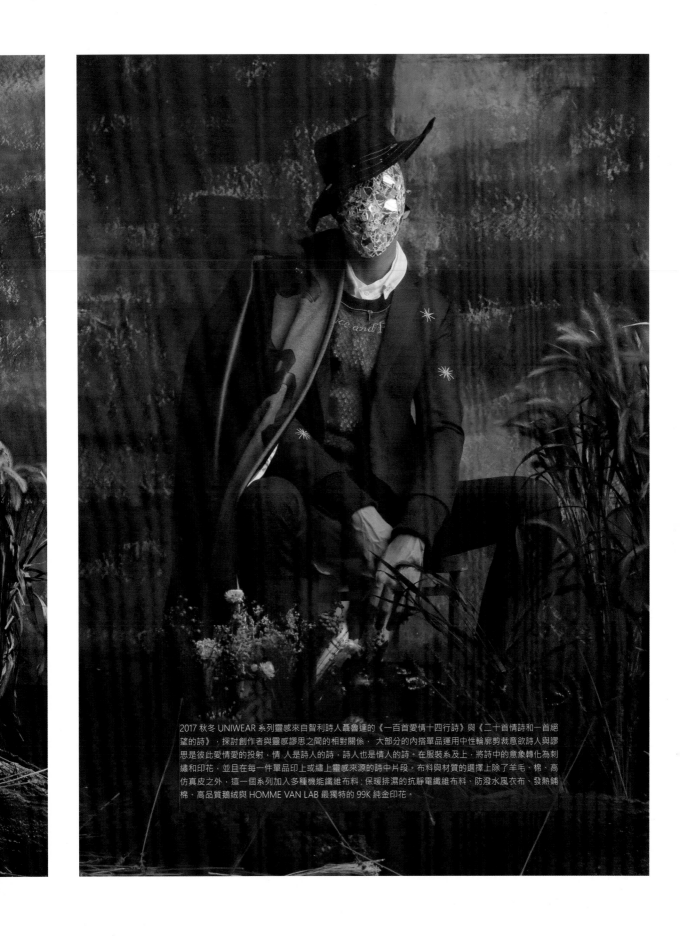

2017 秋冬 UNIWEAR 系列靈感來自智利詩人聶魯達的《一百首愛情十四行詩》與《二十首情詩和一首絕望的詩》，探討創作者與靈感謬思之間的相對關係。 大部分的內搭單品運用中性輪廓剪裁意欲詩人與謬思是彼此愛情愛的投射，情 人是詩人的詩，詩人也是情人的詩。在服裝系及上，將詩中的意象轉化為刺繡和印花，並且在每一件單品印上或繡上靈感來源的詩中片段。布料與材質的選擇上除了羊毛、棉、高仿真皮之外，這一個系列加入多種機能纖維布料：保暖排濕的抗靜電纖維布料、防潑水風衣布、發熱鋪棉、高品質鵝絨與 HOMME VAN LAB 最獨特的 99K 純金印花。

JUBY CHIU

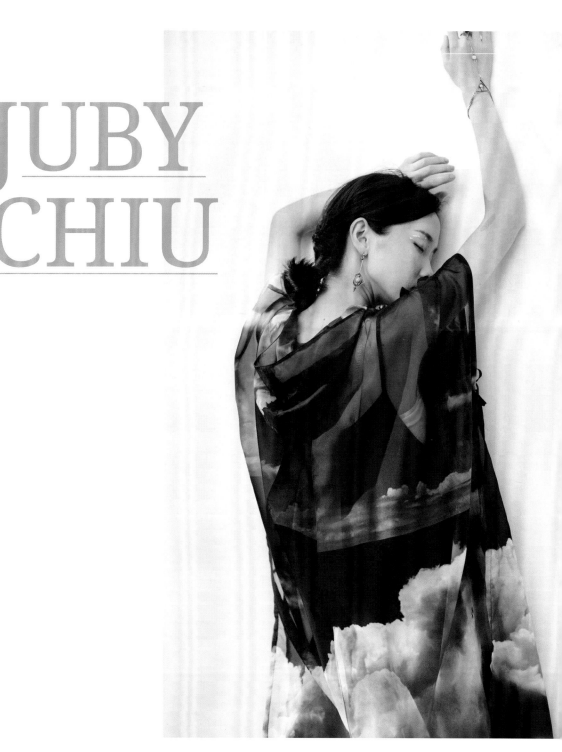

NATION /
TAIWAN

DESIGNER /
Juby Chiu

BRAND /
JUBY CHIU

國家 /
台灣

設計師 /
邱娉勻

品牌 /
JUBY CHIU

AUTHOR SUMMARY

Juby Chiu is grateful to be a witness through her creation. She is a Taiwan based fashion designer.

" Fashion design as for me, is an abstract language to express what I meant. More practically, it's an expression of the internal itself. The essence comes from the internal. It's not only fiber, but also an language between body and soul. "

Before graduating from the fashion design department of Shih Chien Univer- sity. In 2009, Juby achieved the "The honored artist of GEISAI- Japan." In 2010 she participated in "Super Designer" of Taiwan, and she was within the top ranks. In the next year, Juby CHIU won the great achievement prize in the graduation theme. She then went to Europe for internship of the Paris fashion brand "Michel Klein" and to gain competitive edge. After graduation, she took part in the Taiwan Economic Development Council as a featured design- er. In 2011, Juby joined " The Taiwan Fashion Exhibition" and presented the first collection by herself.

In 2012, she founded her own brand as " Juby CHIU STUDIO " and presented her first independent show in Taichung. In the following year, she continues creating a new vision for Taiwan and keeps cross-border alliance with youth artists all over the world. In her free time, Juby devotes her time to doing long term projects with a social conscience. The projects has been exhibited in art museums and culture settlements.

Please describe yourself in a few words

"It's not only fiber, but also an language between body and soul. " The sense of the life experience is internalized and it created countless possibilities.

Juby Chiu Studio / Photographer 張嘉輝

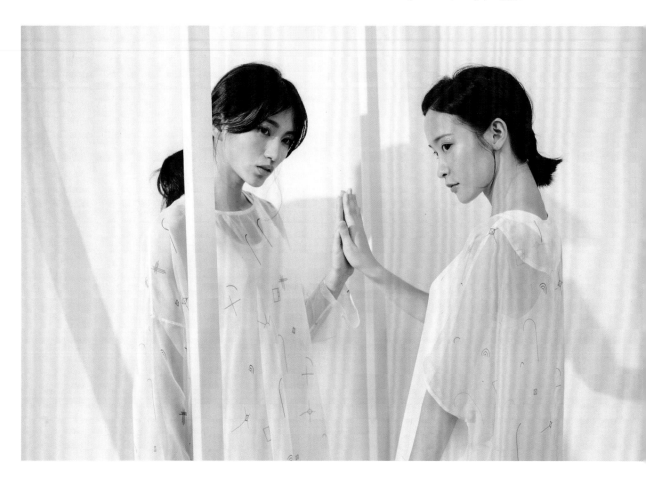

創作者簡歷

邱娉勻很感激能見證自己的創作，她是一名以台灣為基地的時尚設計師。「時尚設計對我來說，是一種抽象的語言，能夠表達我想要說的。」更加實際的，是內在自己的表達。本質來自內在。它是纖維更是靈魂對肉體的一種語言。在 2009 年從實踐大學時尚設計系畢業之前，邱娉勻入圍「日本 GEISAI 榮譽藝術家」，在 2010 年她參加「台視第一屆超級設計師」，成績卓越。隔年，邱娉勻榮獲畢業展卓越成就獎。之後她去歐洲的巴黎時尚品牌「Michel Klein」實習，培養出競爭優勢。在畢業之後，她以特色設計師參加台灣經發會的活動。在 2011 年，邱娉勻參加「台灣時尚展」，並展示她個人首部作品集。在 2012 年，邱娉勻創立了自己的品牌「Juby CHIU STUDIO」，並在台中舉辦她的個人展。接下來一年，她繼續為台灣創造全新的視界，並與全世界的青年 藝術家保持跨國界的結盟。在她的空閒時間，邱娉勻把時間投資在一個長期的社會良知計劃，這個計畫已於藝術博物館和文化聚落展出。

一句話形容自己

「它是纖維更是靈魂對肉體的一種語言」，將生活經驗感官內化後再焠鍊出無 限的可能。

Human, window, and scenery are like human, body fiber, and you using anoth- er way to express the life sceneries and the windows of mind.

Fiber through body, different actions, and movements between lights forms the intangible frame. And the window grille of misplaced pieces is inter- twined by the light and the frame.

Behind each window there is a story about human, moments, and time. Through fiber, symbiosis is hidden in daily life. By crossing and asking for expressing, the self is found gradually and one can move forward.

The snow-white and flawless yarn and the endless sky in the opposite extend the memory of yours and mine. The purity spreads through the window by the sunlight. The light is formed by the body and it becomes the lifelong window grille.

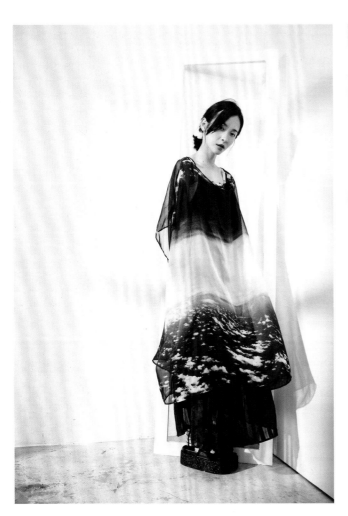
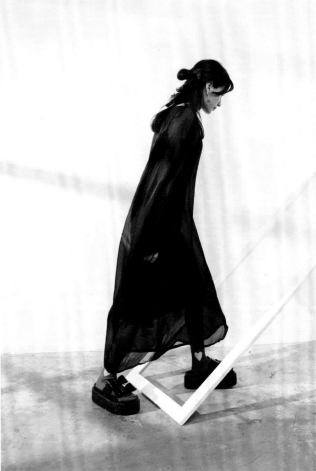

『人、窗與風景就像人與身體纖維與你正在用另外一種方法訴說人生風景與心靈之窗。 纖維，經由肉體、不同的動作和擺動、光與光之間，形成了那層無形的框。 用光線和框交織出錯落片段的窗花。
每扇窗的身後都有一個故事關於人關於瞬間與時光透過纖維，共生關係潛藏於日常，透過穿著尋求訴說，慢慢找回自我進而踏出步伐雪白無瑕的紗、對面是綿延無盡的天空，延續著你我記憶，那純粹淨白透過陽光灑進窗裡，用自己的身體形成光，成為一輩子的窗花。』

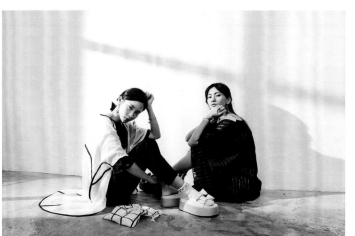
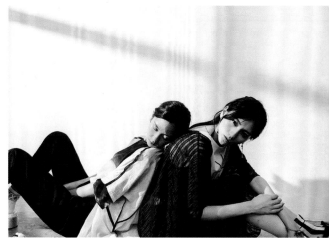
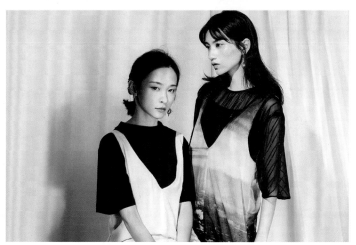
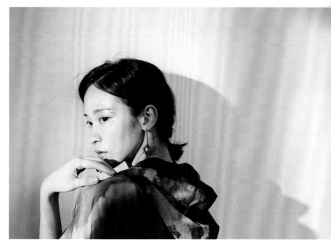

Juby Chiu Studio / Photographer 張嘉輝

ZUO

AUTHOR SUMMARY
I am the design director of ZUO with 15-year experience in women's fash- ion. ZUO is an own branding, founded about 2 years ago. This is the new design of Taiwan which will surprise everyone. The clothes are the creation of fashion and life pace to show individual confidence.

Please describe yourself in a few words
Creative and passionate about the fashion industry.

創作者簡歷
我是 ZUO 的 design director，從事時尚女裝已經有 15 年以上的經驗，ZUO 是屬於自創品牌，創立將近 2 年，這是一個會令大家眼睛一亮的台灣新設計，將時尚結合生活步調詮釋出屬於個人充滿自信的衣著！

一句話形容自己
對時尚業充滿創造力與熱情。

NATION /
TAIWAN

DESIGNER /
Louisa Lin

BRAND /
ZUO

國家 /
台灣

設計師 /
林窈如

品牌 /
ZUO

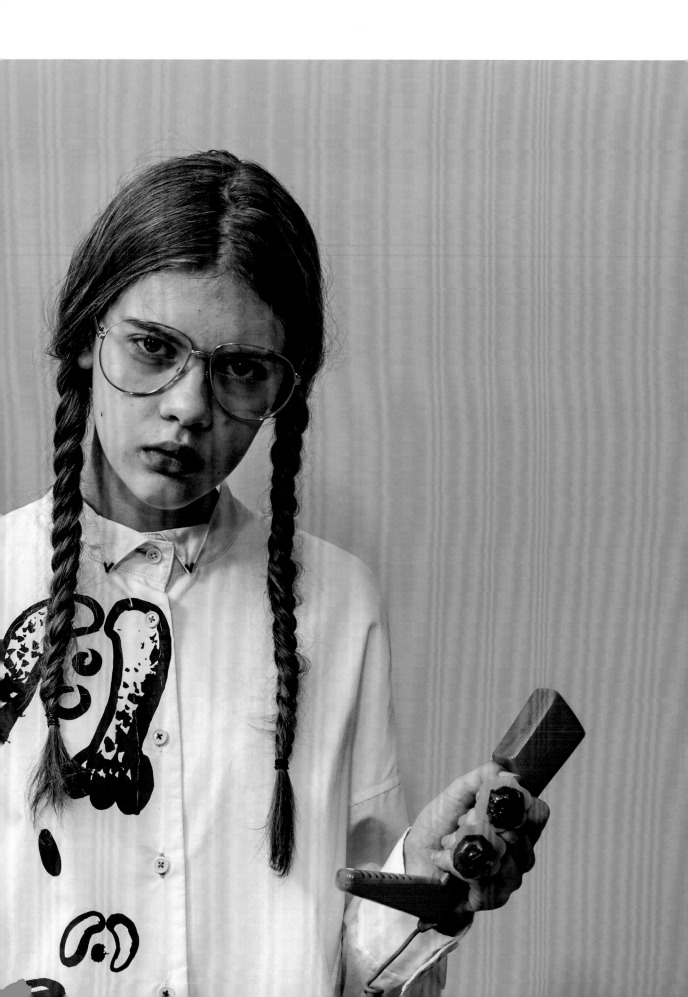

ZUO is created by fun, amusement, and humor.
ZUO always emphasizes the human.We care about the material and techniques, and touch the hearts by simple designs.
Despite the fashionable elements, they are just the soul of the art."Point, line, and surface"The printing of organized patterns subverts and creates and rebuilds visually. The lines of straightness are deliberately processed into obvious and rough seams. The layout and organization adopt the geometric blocks and form the space out of the body.
From the single items, it doesn't bring too strong images.
Natural but unsymmetrical The unsymmetrical proportion is used to make your body shape look slim. The style of patching is one of the characteristics of ZUO.
"The devil is in the details."Mingle with life experience, make the clothes artistic in details.They are very interesting clothes, and the details are the most high-profile showing off.

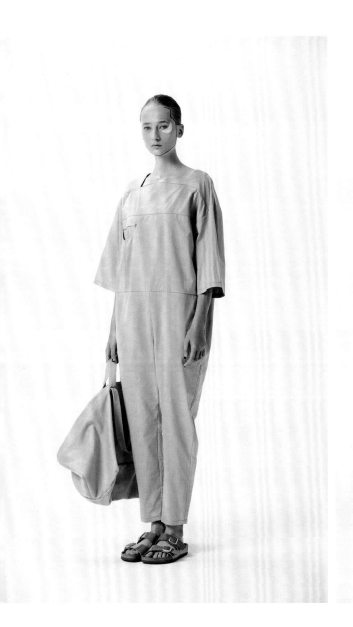

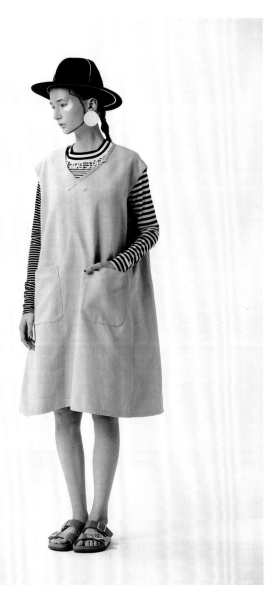

詼諧、趣味、幽默,創造了 ZUO ZUO 始終把人放於第一位重視材質表現與工藝突破,以簡單的設計來觸動人心就算是帶入流行元素,也只是以隱約手法做到點睛效果 "點、線、面" 羅列有致的印花,在視覺上進行顛覆性的創造與重建筆直硬朗的線條,刻意處理成明顯粗糙的縫線版型結構多採用幾何塊面,塑造出身體的外在空間僅從單品來看,卻沒有讓人有過於強勢的印象是自然俐落帶有不對稱的美感而不對稱比例則是用來有效的修飾身型大量的拼貼縫繡手法成為 ZUO 一大特色 "魔鬼藏於細節之中" 融入些許生活感受,用細節把衣服穿成藝術好玩的衣服正是如此,細節才是最高調的炫耀。

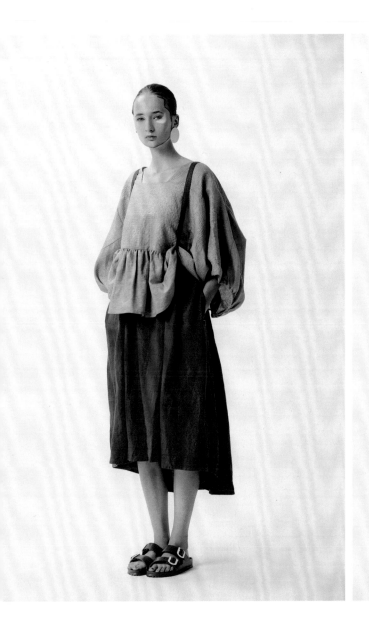
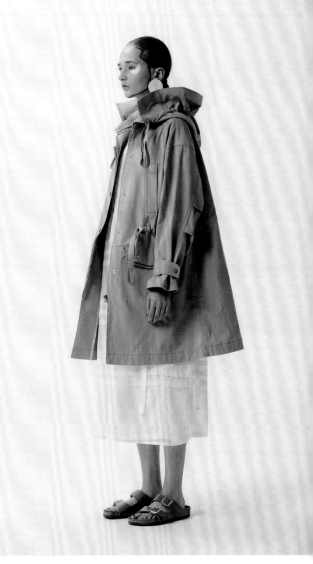

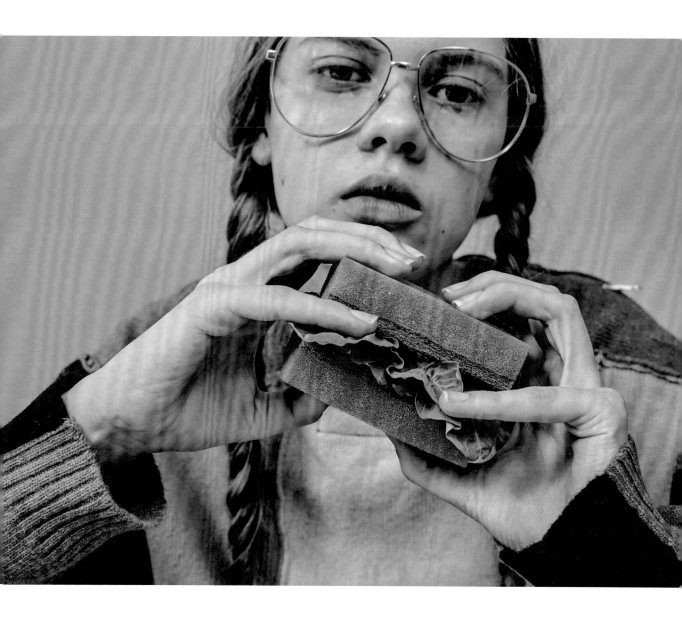

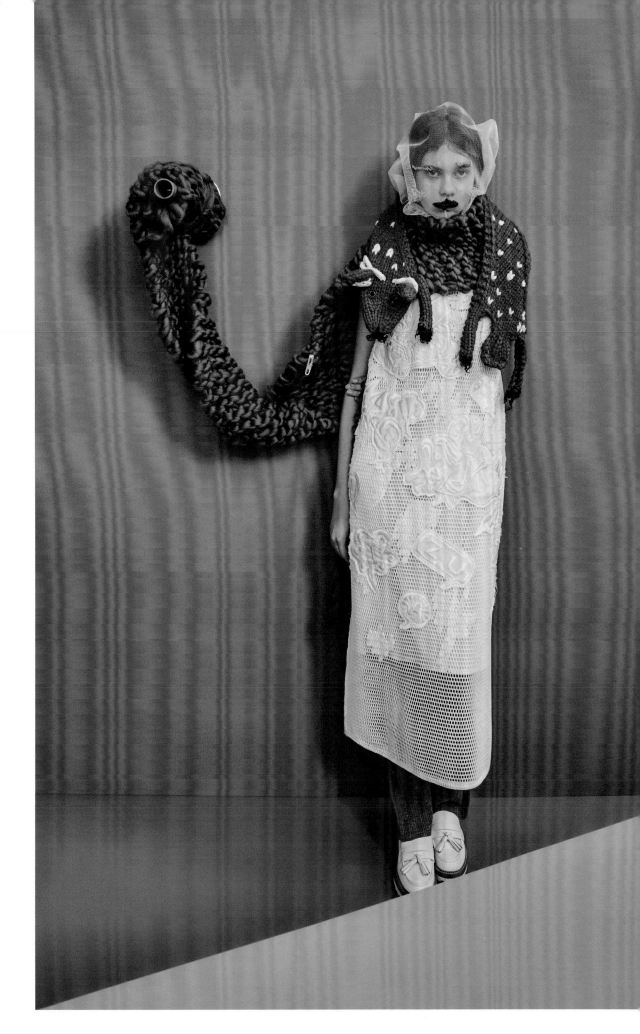

oqLiq

NATION /
TAIWAN

DESIGNER /
Hong Ci
Chia Hao Lin

BRAND /
oqLiq

國家 /
台灣

設計師 /
洪琪
林家豪

品牌 /
oqLiq

AUTHOR SUMMARY

As an upcoming fashion brand in taiwan,oqLiq focus on setting a fashion of outdoor dressing,also engage in crossover between new-tech materials and trendy elements.We believe that cutting can create all kind of possibility.We believe that fashion design should be a joyful experiment by all means.

Please describe yourself in a few words
Design is to combine past aesthetics with modern thinking and create infinite possibilities for the future.

創作者簡歷

嘗試以顛覆的逆常規視角放眼，穿透街頭流行與經典考究，採取高等級科技材質 與精緻裁縫工法，相乘效應出 Made In Taiwan 的時裝設計品牌。

一句話形容自己

設計就是把過去的美學結合現代的思維，創造未來的無限可能。

kung fu
windbreaker plus

Using Taiwanese tech fabric, The first layer is waterproof, the second layer is breathable, and the third layer is warm Fleece material. The high functioning fabric and the Asian cut design makes it Chinese soft shell clothing. The cuffs are rib fabric, prevent them from loosening and cold.

採用台灣科技三層貼面料,第一層為防潑水,第二層為透氣,第三層為 Fleece 保暖層,將東方剪裁比例搭配高端機能面料,成為華夏版本的軟殼衣,袖口佐以防鬆羅紋,不讓寒冬透露。

Resemble
shirt

The strokes of Chinese characters is a kind of design for thousands of years.
"By(以)" is changed into trim lines, front flies, and pockets.
And the "person(人)" who is wearing the clothes combines with the design rationale to become "alike(似)". The combination of "by(以)" and "person(人)" is the interest of the deep and profound Chinese characters. The shirts are made of cotton fabrics knitted by using traditional methods. The dimensional weaves of the vertical and horizontal lines. The warm taste of vintage is brought onto the shirts, which changes the clothing patterns of the shirts. The tangible front flies extend from the left upper collar to the right lower corner. The oblique collar without the harness can be used as jacket collar. The vertical belts on the right chest and two unequal double-piping pockets are presented like the "by(以)". The sense of leaps emphasizes the key points on plain fabric.

中文字的筆畫一種數千年累計的設計,將 "以" 字轉化為裁切線 / 門襟 / 口袋,而穿著這件衣服的 "人" 把整個設計理念貫穿成為 "似","人" 與 "以" 的結合,正是中文字博大精深的趣味。選用仿舊古布織法的純棉布料製成,經緯線堆疊出的凹凸立體織紋,替襯衫抹上些許古著的溫暖韻味,整體為襯衫變形版型,由左領延伸至右下擺的隱形門襟,俐落的斜領卸下扣具後也可變化成夾克領片,右胸前的本布垂直織帶與兩個不規則的雙滾邊口袋,是 "以" 字的呈現,在素面布料上增加的跳躍感點出重點。

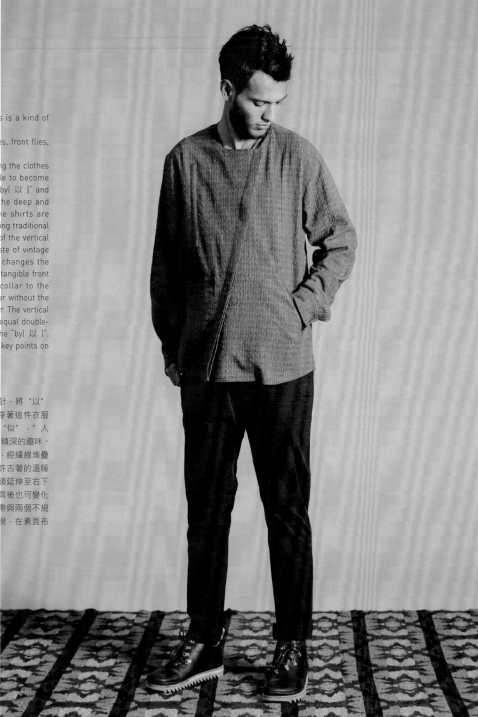

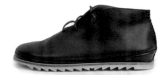
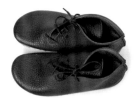

island 4R

The design philosophy of oqLiq's Island Boots is based on a distinctly oriental cast of mind. The instep opening was deliberately slanted to make the asym- metry of the oriental design compatible with the stylistic conventions of different cultures. And the sole and sides are made of one piece of leather, stitched together at the top of the rounded toe and sewn up with a back seam, making the boots simple and elegant, and most of all, soft and comfort- able. It is because of the fact that we use the traditional whole-cut and blake welt technique to make boots, and thus oqLiq's Island Boots have no stitching on the upper vamp, making our boots so unique and distinguished.

Our ideal is to take advantages of all sorts of valuable resources in Taiwan, so as to create a brand-new fashion style. For example, our superior soles are provided by DR. SOLE, anticipating to give you the most comfortable feeling during your daily walking. Creating new classics is our ultimate ambition. Dedicated arts & neoclassics, it is the style of oqLiq. We hope you like it.

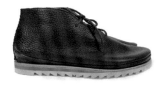
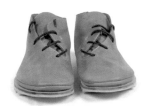
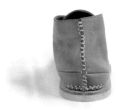

發展一種東方斜衽氣質的島靴，華夏系服是右衽，夷族是左衽，而鞋有左右對稱，象徵一種文化融合。

而側面看有印弟安莫卡辛鞋的氣質，柔軟實穿，在做工上採用 wholecut 是西方紳士鞋最高等級的做法，採用一片式簡裁，但應用在休閒鞋是一種休閒與正式概念的整合，一個襪靴的傳統工藝，整體成形之後才手工縫製中底而後再粘合大底 blake welt，這是在工業化膠水黏著之前被捨棄的頂真做工，這雙台灣製造的鞋，我們的理想就是在這個文化融合的地方，擁有各種加工的高級技術背景，我們應 該善用這樣的優勢，所以我們創造更新的風格，鞋底採用 DR.SOLE 超柔軟鞋底可折 180 度的柔軟韌度，希望穿著的人能擁有球鞋一般的舒適度，創造新的經典，是 oqLiq 的野心，慢工藝 X 新經典，希望各位喜歡。

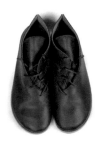
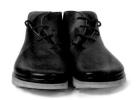
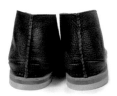

island 4R

Pieces of wool stitch the classic diamond checker pattern combining with the material of neckties. Careful creasing lines elevate the sense of third dimen- sion. It deduces the connection between Eastern KIMONO and suits.

The cutting and the design adopt the pictogram character "water (水)" to be the deduction of ROOT in this season. Full cover and empty lining complete this design. Eighty percent of regular sleeves offer more possibilities for outfit. This is the golden triangle of the diverse cultural fusion. It is the classic item of oqLiq in this season.

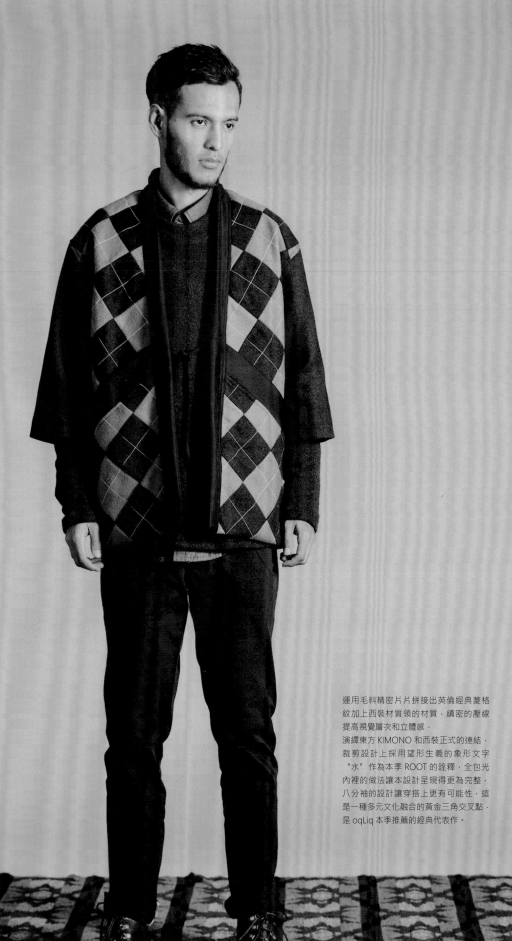

運用毛料精密片片拼接出英倫經典菱格紋加上西裝材質領的材質，縝密的壓線提高視覺層次和立體感，

演繹東方 KIMONO 和西裝正式的連結，裁剪設計上採用望形生義的象形文字 "水" 作為本季 ROOT 的詮釋，全包光內裡的做法讓本設計呈現得更為完整，八分袖的設計讓穿搭上更有可能性，這是一種多元文化融合的黃金三角交叉點，是 oqLiq 本季推薦的經典代表作。

MA-1 orient jacket

oqLiq launched the updated version of MA-1 in this season. The design of Chinese placket provides one more option for fans of parka wears. The front part uses six-line perforation to strengthen the durability. Covered buttons of the twill nylon of the same material fuse the western and eastern styles. The highest level of DuPond patented 7-hole padded cotton is the basic accessory of winter. The twill nylon of military use is very light and warm. The pockets on the upper arms simplify the curve of MA-1. The minimalistic water proof zipper is the visual highlight. The classic lining luxuriously uses the bright orange twill nylon which makes MA-1 classic. To improve the functionality, a pocket is added inside.

oqLiq 本季推出改版變種版本 MA-1，漢系的開襟設計讓軍裝迷多了一個新的選擇。前襟上是採用六線壓線增加軍事規格的耐牢度，同材質斜紋尼龍的包扣把東西方的氣味融合到極致，以最高規格的杜邦專利七孔撲棉作為過冬的基本配件，軍規等級的斜紋尼龍輕暖特色不在話下，上臂口袋簡化 MA-1 的線條，極簡的防水拉鏈成為視覺上的亮點。 經典的內裏是奢侈的採用亮橘色斜紋尼龍考究了經典的 MA-1，心機的添加一個內襯口袋增加了穿著上的機能性。

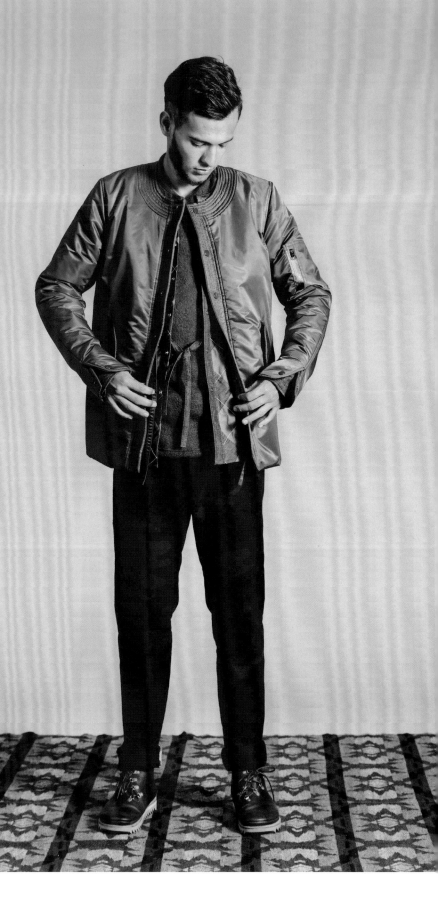

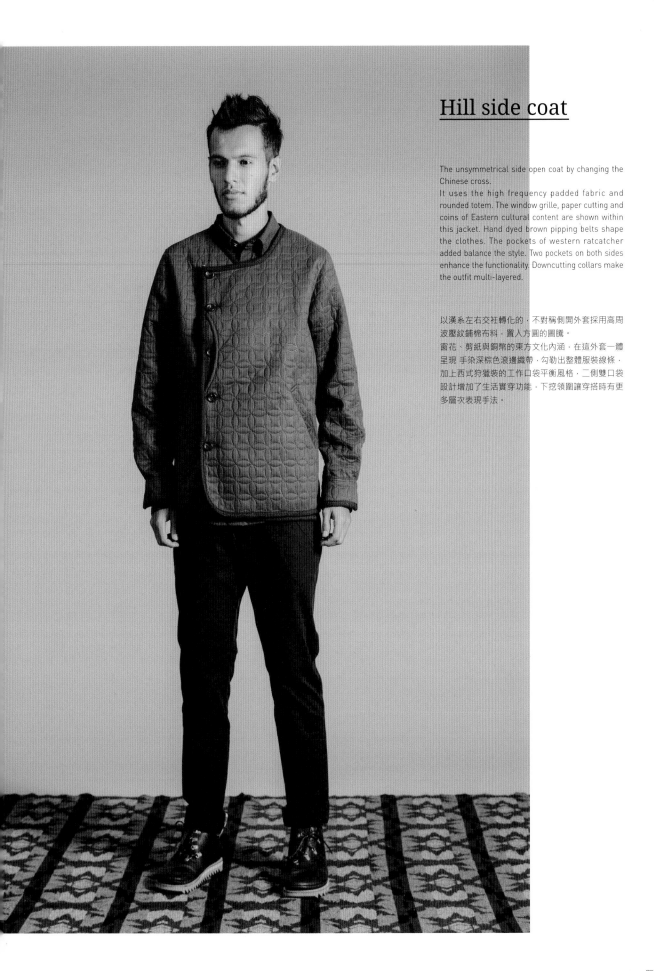

Hill side coat

The unsymmetrical side open coat by changing the Chinese cross.
It uses the high frequency padded fabric and rounded totem. The window grille, paper cutting and coins of Eastern cultural content are shown within this jacket. Hand dyed brown pipping belts shape the clothes. The pockets of western ratcatcher added balance the style. Two pockets on both sides enhance the functionality. Downcutting collars make the outfit multi-layered.

以漢系左右交衽轉化的，不對稱側開外套採用高周波壓紋鋪棉布料，置入方圓的圖騰。
窗花、剪紙與銅幣的東方文化內涵，在這外套一體呈現 手染深棕色滾邊織帶，勾勒出整體服裝線條，加上西式狩獵裝的工作口袋平衡風格，二側雙口袋設計增加了生活實穿功能，下挖領圍讓穿搭時有更多層次表現手法。

國家圖書館出版品預行編品 (CIP) 資料

AAD 亞洲傑出時尚創作精選 / 陳育民總編輯 ,-- 高雄市：
陳育民 , 2017.12

ISBN 978-957-43-5203-6〔平裝〕

1. 設計 2. 時尚 3. 亞洲

960 106023900

書名 Book Title	AAD 亞洲傑出時尚創作精選
總編輯 Editor-in-Chief	陳育民 Chen,Yu-Ming
編輯企劃 Editing	宋佩軒 Song, Pei-Syuan
	鄧以婷 Deng, Yi-Ting
	蔡宜君 Cai, Yi-Jyun
	孫守蓉 Sun, Shou-Rong
視覺設計 Graphic Design	五十 Fifty（未茉設計 Wemore Design Studio）
翻譯人員 Translator	呂季璇 Lyu, Ji-Syuan／石岡 Aaron Shi
出版者 Publisher	陳育民 Chen,Yu-Ming
版次 Edition	初版 First Edition
出版日期 Publishing Date	2017/12
ISBN	978-957-43-5203-6〔平裝〕
聯絡信箱 Mail	aadfashion2017@gmail.com

ISBN 978-957-43-5203-6

9 789574 352036

TAIWAN 台灣

OVKLAB	莊哲瑋
Liou Shing-Luen	劉興倫
Chen Ying-Chia	陳盈嘉
SYChen.Shoes	陳思伃
JOLIN WU	吳若羚
JENN LEE	李維錚
Lin Yang-Hong	林洋弘
SUMI	李向明
HOMME VAN LAB	張暘
JUBY CHIU	邱娉勻
ZUO	林窈如
oqLiq	洪琪/林家豪

AAD AAD FASHION # TAIWAN

www.facebook.com/AADFashion2017/
aadfashion2017@gmail.com